Contents

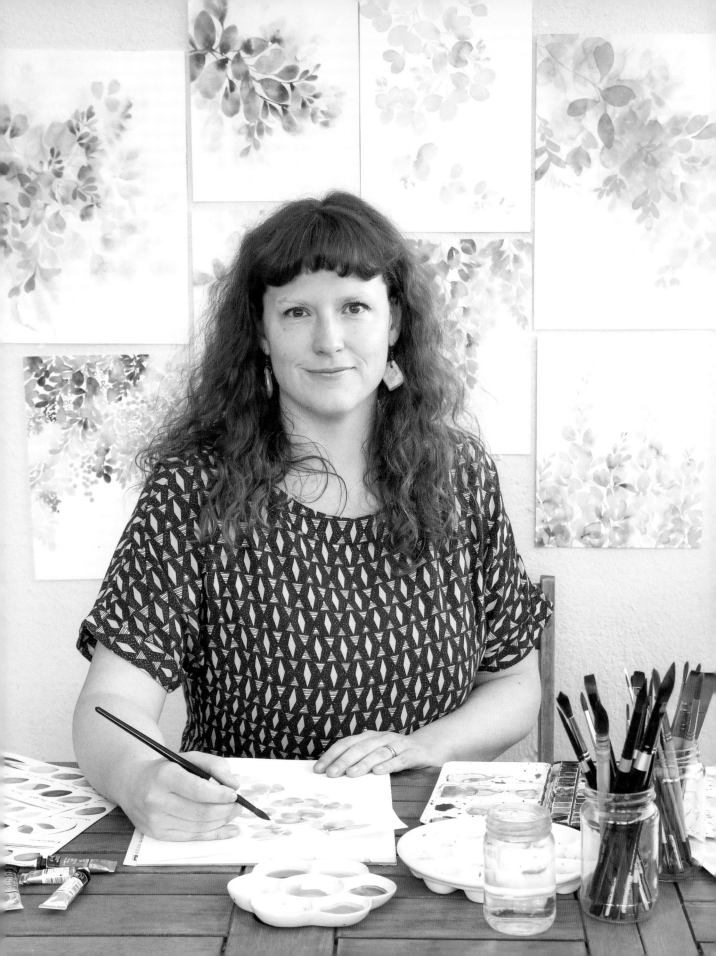

After studying law for two years, in the end I turned to photography and made it my career. My favorite subjects were graffiti, the artists hidden behind these paintings, and abandoned places. I am fascinated by the connection between painting and nature reclaiming its rights. But little by little, the daily routine and the grayness of city life stifled all my desires, to the point that for a period of my life, I no longer had any activity that stimulated my imagination.

I had to leave the city for the countryside to rediscover my creative soul and to explore this world that had become unknown to me. A leaf, a blade of grass, or a cloud has a much greater evocative power than any urban element. Shortly thereafter, I threw myself into watercolor, and my fascination with this medium only grew over time. There is something magical in observing the reaction between water and pigment, seeing the colors diffuse, and being able to create with ease.

I firmly believe that nature, inspiration, and imagination are inextricably linked, and for me, one doesn't work without the others. I am an eternal optimist, and I believe that it is never too late to learn and that the hardest part is taking the first step. This is why I launched my website in 2019, to share both step-by-step watercolor ideas and also inspiration across the seasons.

Website: mirglis.com
Instagram : @mirglis

Paint and Paper

Paint

Watercolors consist of a binder, most often gum arabic; pigments; and a wetting agent. They come in two qualities: fine or extrafine. The extrafine variety is richer in finely ground pigments, which makes it more expensive. It comes in a pan (as a solid) or a tube (as a paste). What makes watercolor special is that it can be reactivated with water, making it infinitely reusable: You'll find that a pan lasts a long time!

To get started, I suggest getting yourself a box of fine watercolors in half-pans containing a dozen colors, including the three primaries (blue, red, and yellow) as well as a pink and a gray. The color white is not useful, as the white is actually the white of the paper.

I recommend the Van Gogh brand, which offers several varieties of boxes, or the La Petite Aquarelle set from Sennelier. You can then complete your palette by purchasing individual half-pans of your favorite colors in extrafine quality.

Paper

Watercolor paper is distinct due to its high weight, at least $300g/m^2$. This thickness allows it to better withstand wetness with less curling. As with the paint, you will find different qualities depending on whether the paper is made of cellulose or of 100% cotton. The latter is more resistant to wetness and dries more evenly; it is also more expensive. You will find three textures: hot-pressed (smooth), cold-pressed (also known as "not"), and rough. The cold-pressed paper is the easiest for beginners.

Watercolor paper comes in the form of a block glued together on all four sides, in sheets, or in a pad. The advantage of the block is that your sheets are already fixed in place, allowing you to work easily in the wet. The surface is not the same on both sides, so use only the front side.

Ideally, you would have two different blocks of paper: one of cellulose to make tests, and one of cotton to paint more elaborate creations. Being able to alternate between the two should assuage any fear of wasting paper! I recommend the Fontaine line from Clairefontaine. Its value for money is very good, and it is the one I use throughout this book.

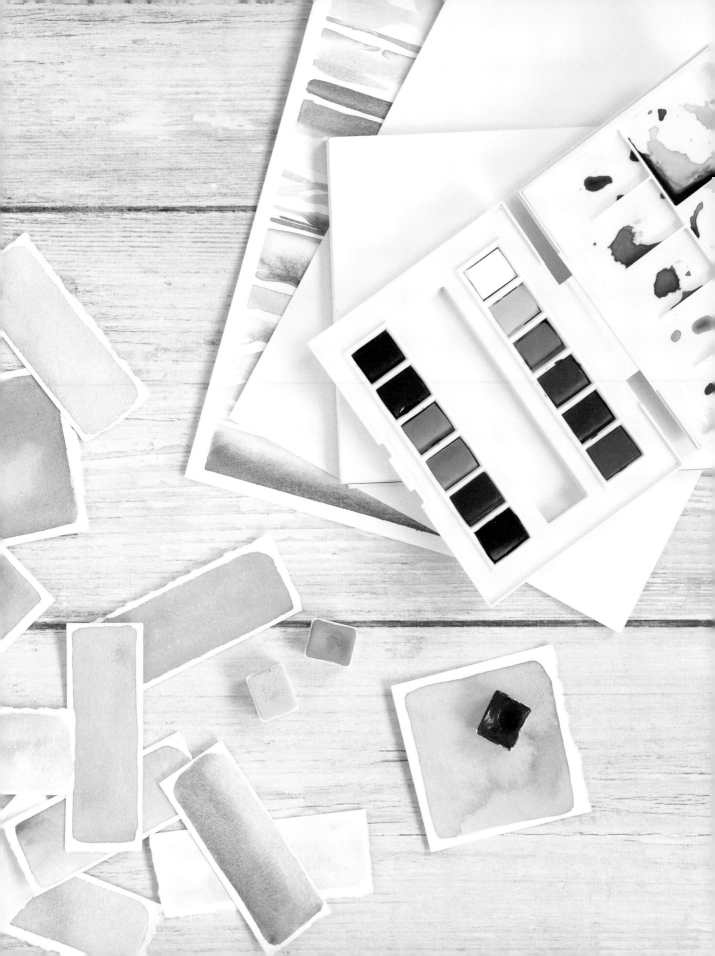

Brushes and Additional Materials

Brushes

There are all kinds of brushes: round, fine, wash, fan … You will find them with synthetic fibers or natural hair and varying in size. This is indicated by the number on the brush handle.

For starting out, I recommend a medium-sized, fine-tipped, flexible round brush that will allow you to paint fine lines but also to create all kinds of shapes. I really like the Neptune range from Princeton; a size 8 works well for multiple uses, and this is the model I use for all the designs in this book. You can also choose to supplement it with a size 0 wash brush to cover larger areas and a very fine brush for details.

Additional Materials

- **A palette** Having a dedicated space to mix colors is essential because watercolor is never used directly from the pan; the paint needs to be diluted before being applied to the paper. Whether plastic or porcelain, the important thing is that the palette is white so that the colors are true. If you don't want to invest in a palette right away, you can also use the inside cover of your watercolor box.

- **A cup of water**

- **A cloth or paper towel**

- **A pencil and an eraser**

- **Drawing gum and a thin, low-end brush for application** Drawing gum or masking fluid is a thick liquid used to preserve the white of the paper. Its gluey consistency will quickly damage a brush, which is why I recommend using a cheap brush.

- **Painter's tape or masking tape**

- **Household materials for creating textures:** Table salt, white ink, 90% rubbing alcohol, cotton swabs.

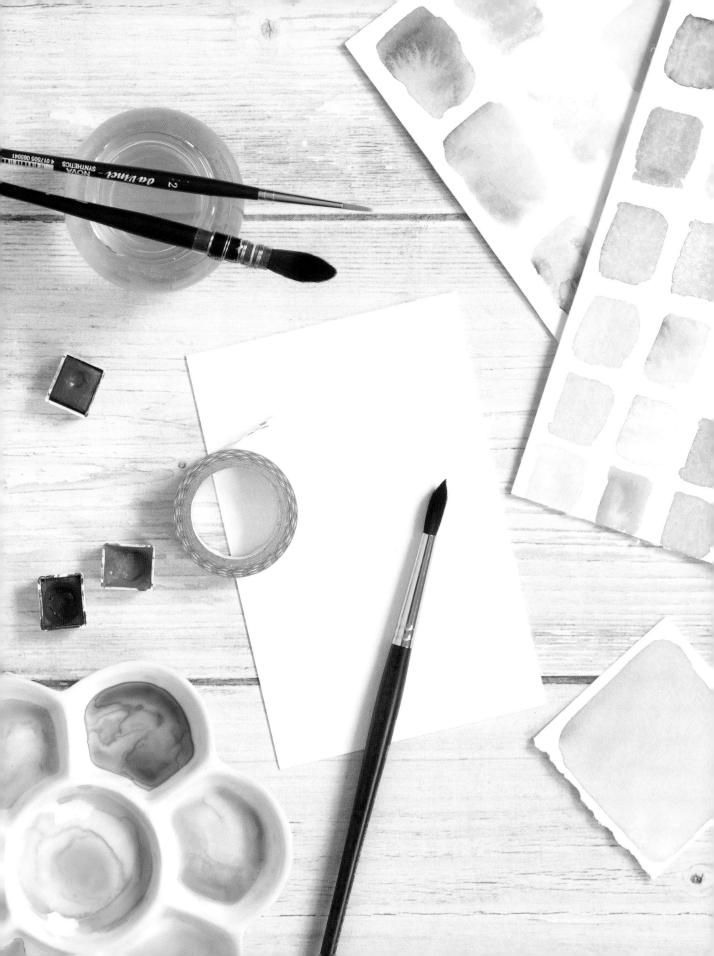

Mastering Color

Creating a Color Chart

A color chart is the perfect first step for discovering how watercolor works and getting to know your materials. The final result of a color is very different from what you see in the dry pan, so making a color chart lets you know what each color really looks like. Because you will refer to it later, it's important to place the colors in the exact same order as on your palette for easier reference.

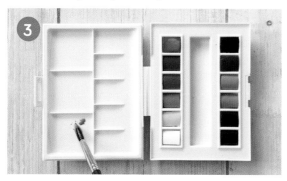

Dip your brush in your cup of water and wring it out around the edge to remove excess water. You will need to do this every time you rinse your brush.

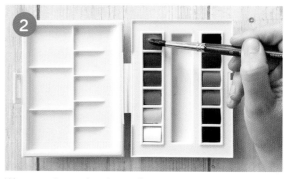

Wet your first color, then take some paint with the tip of your brush.

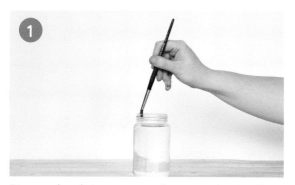

Place this color on your palette.

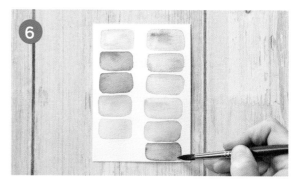

Next add a little water to dilute it.

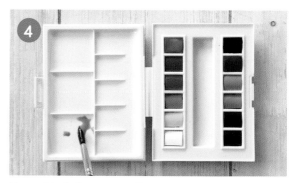

Place this color on the paper to form a rectangle. Rinse your brush well so as not to alter the next color.

Repeat this process for each color.

Creating a Color Wheel

You can create a color wheel with any primary colors: a red or a pink, a blue, and a yellow. You can create a variety of colors with these three primaries; no need to invest in a multitude of pans to start creating. By referring to this wheel later, you will know at a glance what mixture to make in order to obtain a color. Avoid mixing more than two colors at the same time or else you may get brown or gray!

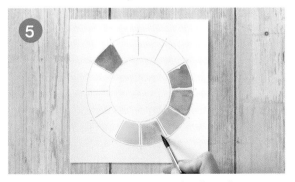

Draw a circle with a pencil and divide it into 12 equal parts.

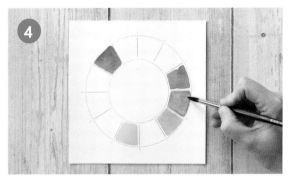

Place the 3 primary colors (red, yellow, and blue) at an equal distance.

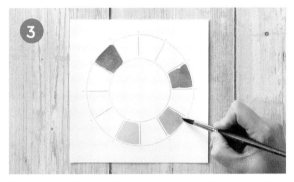

On your palette, mix the same amount of red and yellow to get an orange and place the resulting color on the circle. This is a secondary color.

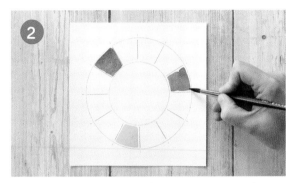

Now mix the same amount of orange and red and place that color on the circle. This is a tertiary color.

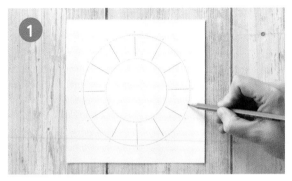

Finish with a mixture of orange and yellow; this is again a tertiary color.

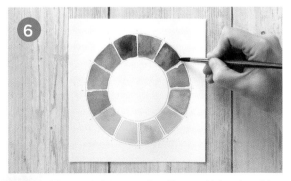

Repeat the same process with yellow and blue, then blue and red.

Creating a Color Palette

There are different types of color palettes to refer to when starting out. To add contrast, vary the intensity of the colors by diluting them more or less, but also the proportion of each color used. Your color wheel will be useful in identifying the different patterns.

• **Monochrome Palette** To achieve a dynamic work with a single color, you will have to use its full potential by using both very dark and very light tones.

• **Analogous Palette** Composed of adjacent colors on the color wheel, this is a palette that never fails. As the colors are close to one another, it's very easy to obtain a harmonious final product.

• **Complementary Palette** This brings together diametrically opposed colors on the color wheel. This palette has pep. Vary the proportion of each color to avoid too garish a result.

• **Triadic Palette** This is made up of evenly spaced colors on the color wheel. Rather easy to compose, this palette combines a fairly wide variety of colors.

• **Customized Palette** You can also choose your colors outside the realm of traditional patterns. By limiting yourself to three or four colors, it will be easier to obtain a harmonious result and encourage you to vary the intensity of the colors.

Introduction to the Colors Used in This Book

All of the projects in this book were made using twelve of my favorite colors. I use the Sennelier brand. Depending on your own materials, you will be able to obtain identical or similar shades.

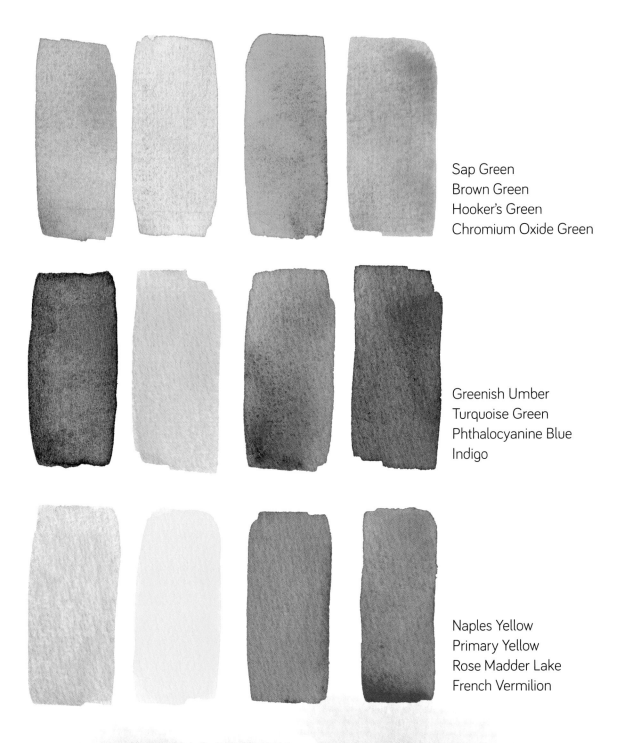

Sap Green
Brown Green
Hooker's Green
Chromium Oxide Green

Greenish Umber
Turquoise Green
Phthalocyanine Blue
Indigo

Naples Yellow
Primary Yellow
Rose Madder Lake
French Vermilion

Tropical Plants

Techniques

Brush pressure and amount of water
Wet on dry

Knowing your brush and how to use it is an asset because a single brush is enough to achieve a multitude of effects. The tip lets you paint thin lines while the full head allows you to create thick marks. By simply varying the pressure, you'll be able to obtain a whole range of shapes, both rounded and pointed. We will start by exploring the "wet-on-dry" technique. This simply means applying wet paint to a dry sheet of paper. It offers the most control and allows you to achieve a precise result. Plants are an ideal subject for getting started because they let you master your brush while you create a refreshing world.

Materials

- Primary Yellow
- Brown Green
- Sap Green
- Hooker's Green
- Turquoise Green
- Narrow painter's tape
- 300 g/m², 100% cotton, cold-pressed watercolor paper
- Pointed round brush, medium size (size 8)

Palette

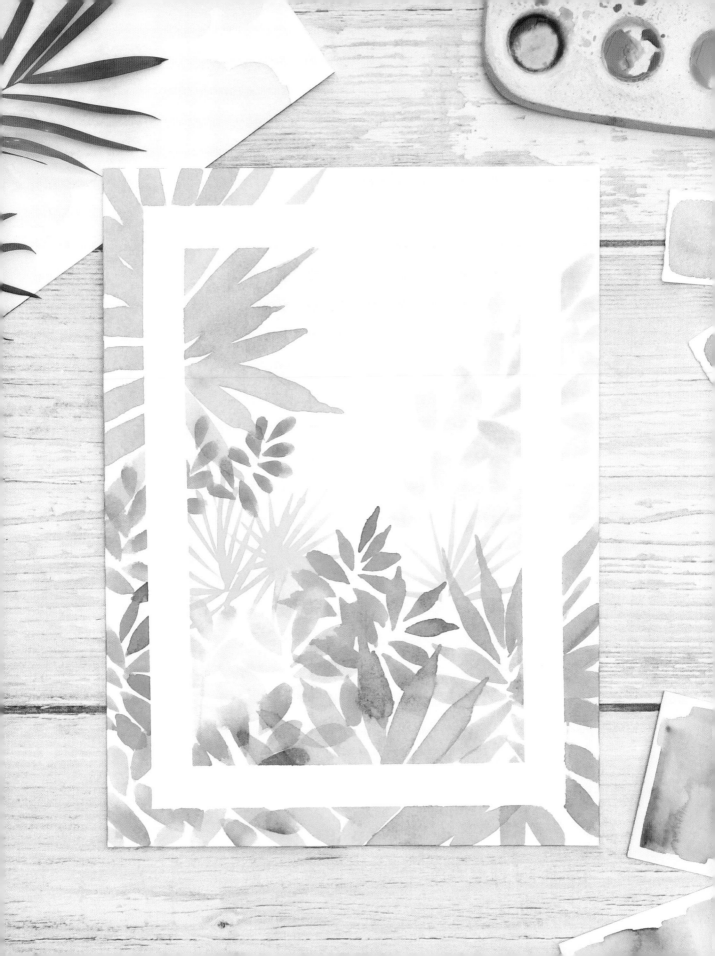

Step 1

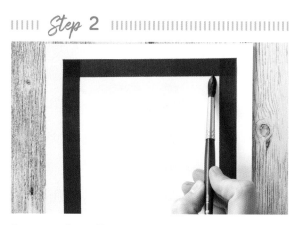

Use the masking tape to create a rectangle about 1cm ($^3/_8$in) from the edge of your paper. This will preserve the white and thus create a margin.

Step 2

On your palette, dilute your turquoise to get a very light shade. Prepare enough to cover the entire sheet. We are now going to paint a wash to cover the entire surface of the paper. First paint the inside of the frame, starting with a line at the top; apply decent pressure to your brush to create a thick line.

Step 3

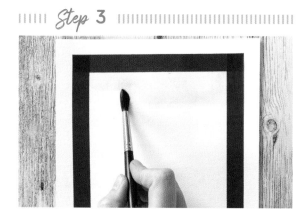

Reload your brush with turquoise and then paint a line below the first one, starting this time on the opposite side. Repeat this movement back and forth until you have covered the entire sheet.

Step 4

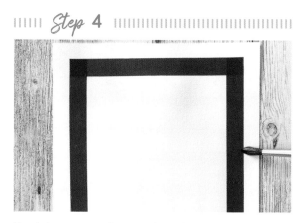

Finish by painting the outside of the frame, then let dry completely.

Step 5

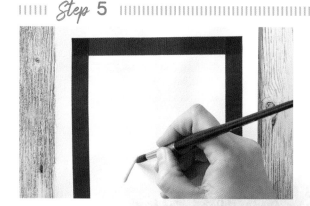

Using diluted yellow, start by drawing a thin line using only the tip of the brush. Don't press too hard; imagine just skimming the paper, always applying the same pressure to the brush.

Step 6

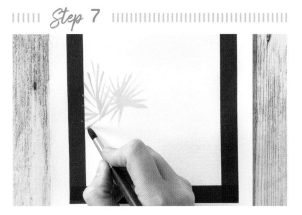

Repeat this same movement to create a palm tree by making lines from a central point outwards. Do not overload your brush with paint; this will give you more control over the line.

Step 7

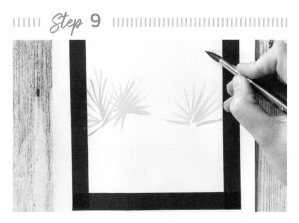

Paint a second palm tree to the left of the first one. Don't hesitate to vary the length of the lines as well as the orientation so that it differs slightly from the first.

Step 8

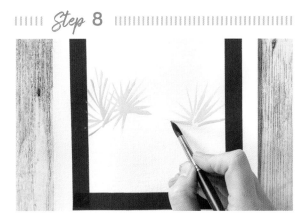

Add a third palm tree on the right side of the paper using the same process. When you feel comfortable, start giving more forceful brushstrokes. You will find that your lines will be straighter and more dynamic.

Step 9

We are now going to paint a different shape. With your turquoise, start by placing the tip of the brush on the paper to create the very beginning of a fine line.

Step 10

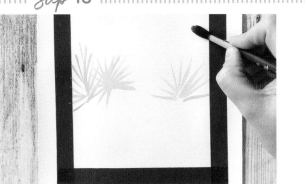

Completely press down the rest of the brush head to create a rounded shape. The more you press, the thicker the mark.

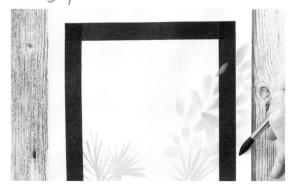

Repeat this "tip-press" movement, varying the orientation of the brush in order to create a tuft of leaves. Don't hesitate to turn your paper so that you are always in a position in which you feel comfortable.

With Hooker's Green mixed with turquoise, add 2 more groups of leaves, this time painting thinner shapes. To do this, repeat the "tip-press" movement, pressing down just a little less, with a brush lightly loaded with pigment.

Using only Hooker's Green, create a third group of smaller leaves. Again, apply a little less pressure on your brush to create a smaller round shape.

Add a last tuft of leaves at the very bottom, making them thicker. Don't hesitate to paint directly on the tape; you don't need to avoid it.

We are now going to paint a different type of leaf by once again varying the pressure on the brush. With the Brown Green, start by resting the tip of the brush on the paper.

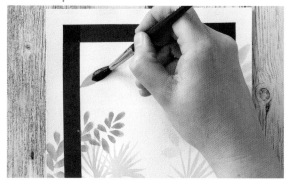

Now press the brush head while moving it in order to create a thicker line.

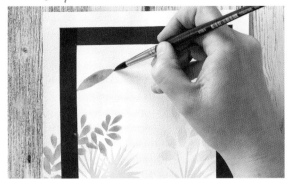

Continue this movement, gradually easing the pressure to finish with only the tip of the brush. This will give you a pointed end.

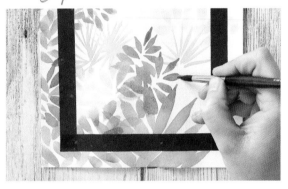

Repeat this "tip-press-tip" movement to create the shape of a palm tree, still painting on the tape. This time you can generously load your brush to be able to paint each leaf in one movement.

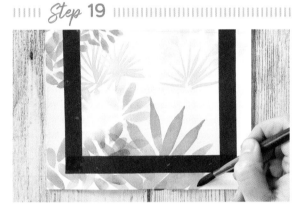

Still with this green, add a second palm tree at the very bottom, using the same motion.

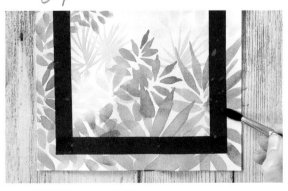

With Hooker's Green mixed with Sap Green, continue painting groups of leaves, making them smaller. To do this, repeat the "tip-press-tip" movement, applying less pressure to your brush.

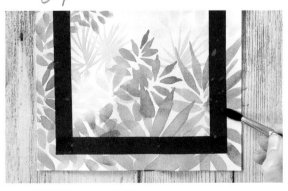

Finish by adding one last larger palm tree on the right side, this time making very thick lines.

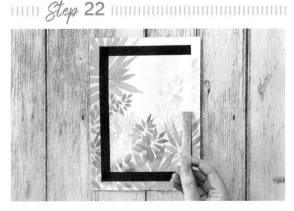

Let dry completely before removing the tape. To do this, peel off one end and pull it toward you; this reveals the white of the paper.

Spring Carrots

Technique

Gradients

Making a gradient allows you to go from a light area to a darker area or from one color to another in a subtle and seamless way. This technique lends itself to all types of subjects (leaves, sky, insects, etc.) and is ideal for beginners.

Materials

- Naples Yellow
- French Vermilion
- Sap Green
- Pencil and eraser
- 300g/m², 100% cotton, cold-pressed watercolor paper
- Pointed round brush, medium size (size 8)

Palette

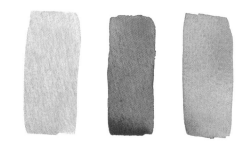

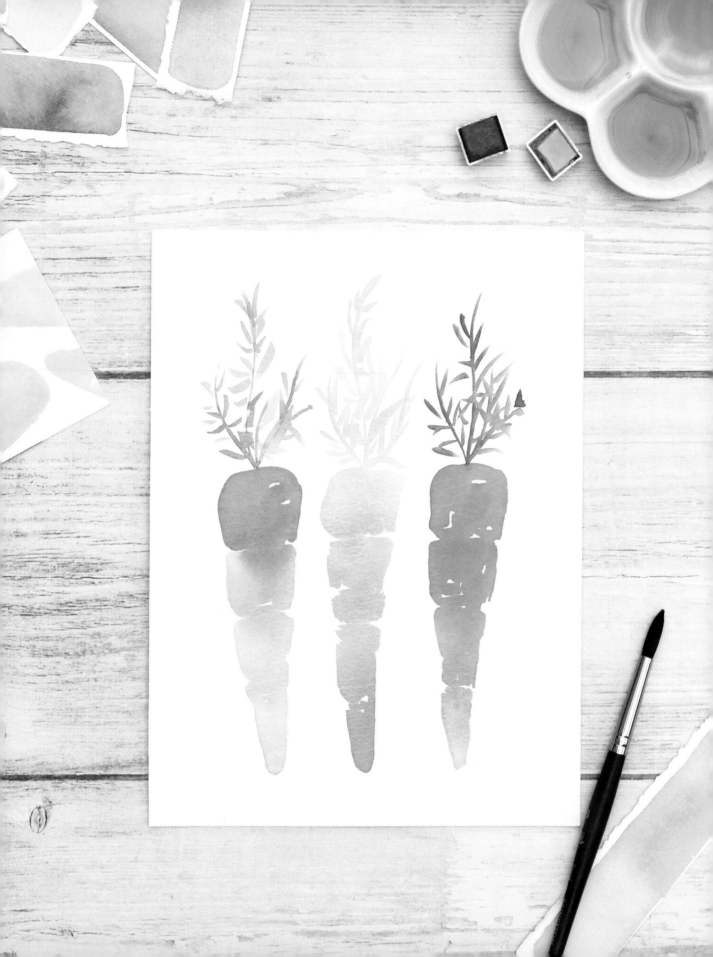

Draw 3 triangles with a pencil without applying too much pressure; this way, the lines will not be visible under the paint.

On your palette, mix French Vermilion and Naples Yellow to get an orange.

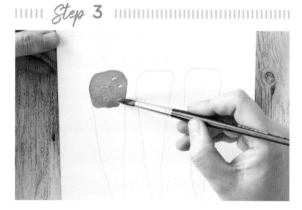

To paint the first carrot, we are going to make a gradient from darkest to lightest. Start with the one on the left and paint the top quarter orange, moving from top to bottom. Tilt the paper so that it points downward.

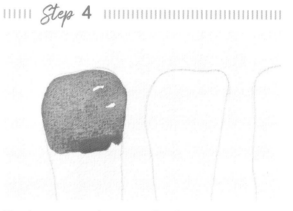

Thanks to gravity, the paint will collect at the bottom of the area you just painted and form a little pool.

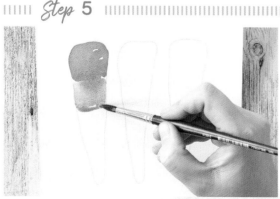

Dip the brush in water once and remove the excess water. The goal is not to rinse it completely but to dilute the orange slightly. With your brush, collect the pool already formed and paint the second quarter of the carrot, still moving from top to bottom.

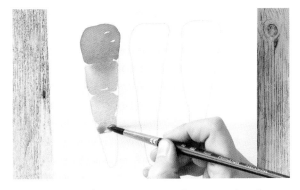

Continue using the same process: Rinse your brush once and remove the excess water, then paint the third quarter of the carrot by collecting the pool, always keeping your paper tilted.

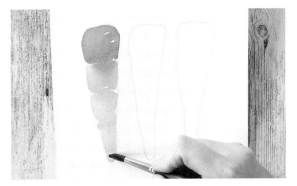

Repeat this process to the carrot's tip. Finish by wiping the brush and sucking up the drop formed at the bottom of the tip. All of these steps must be executed quickly so that the entire carrot is painted before the paint begins to dry.

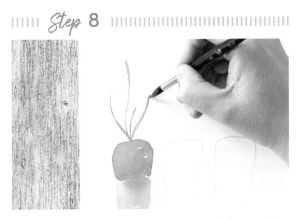

Trace the stems with Sap Green, using only the tip of the brush so as to make fine lines.

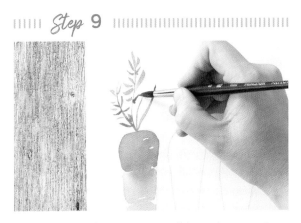

Add the leaves by painting small lines that start from the stem. Vary your brush pressure to create different thicknesses so the leaves will all look different. This first carrot is now complete!

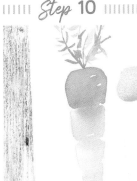

For the second carrot, we'll now create a gradient between 2 colors, from yellow to orange. Paint the top quarter with yellow.

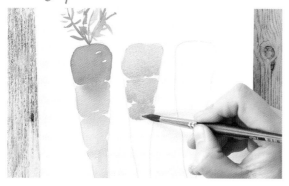

Rinse the brush and add a hint of red to the yellow on the palette. Mix to obtain a slightly orangey yellow. With this color, paint the second quarter of the carrot, collecting the pool formed at the bottom of the previously painted area.

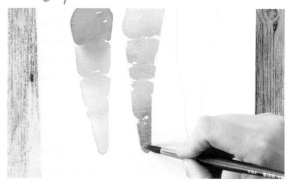

Continue using the same process, painting the last 2 quarters of the carrot, adding red each time. The tip of the carrot should be very orange. Once again, finish by wiping your brush and sucking up the drop at the bottom of the tip.

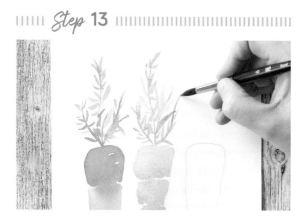

Paint the stems and leaves in the same way as before, using Sap Green mixed with orange.

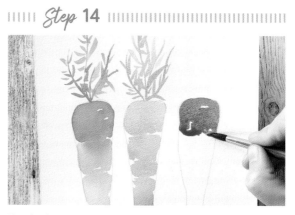

For the last carrot, we will use the same technique, but this time making a gradient between red and yellow. Paint the first quarter of the carrot red.

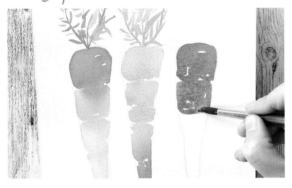

On your palette, add a touch of yellow to the red to obtain a slightly orangey red, then mix. Use this mixture to paint the second quarter of the carrot.

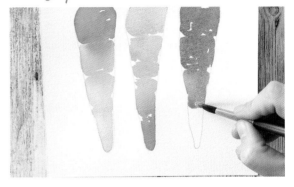

On your palette, add a touch of yellow again to the previous mixture and use the resulting color to paint the next area.

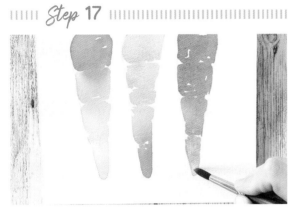

Paint the last area using yellow.

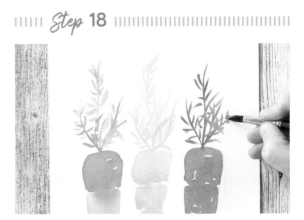

Finish with the stems and leaves using Sap Green. Let dry completely before erasing the pencil.

Green Leaves

Techniques

Transparency and layering colors

Transparency is a specific feature of watercolor. The more a color is diluted, the more transparent and luminous it will be, revealing the white of the paper. This property allows you to play with depth by superimposing successive layers. Always apply the lightest, most diluted color first, gradually working toward darker, more pigmented tones. This transparency also means that a color cannot be lightened once it's been applied to the paper. Don't rush; let it dry well before applying the next coat. You can speed up the process with a hair dryer if necessary. Transparency is a technique that you will use regularly, even without thinking about it, every time you construct a painting using several layers.

Materials

- Primary Yellow
- Indigo
- Pencil and eraser
- 300g/m², 100% cotton, cold-pressed watercolor paper
- Pointed round brush, medium size (size 8)

Palette

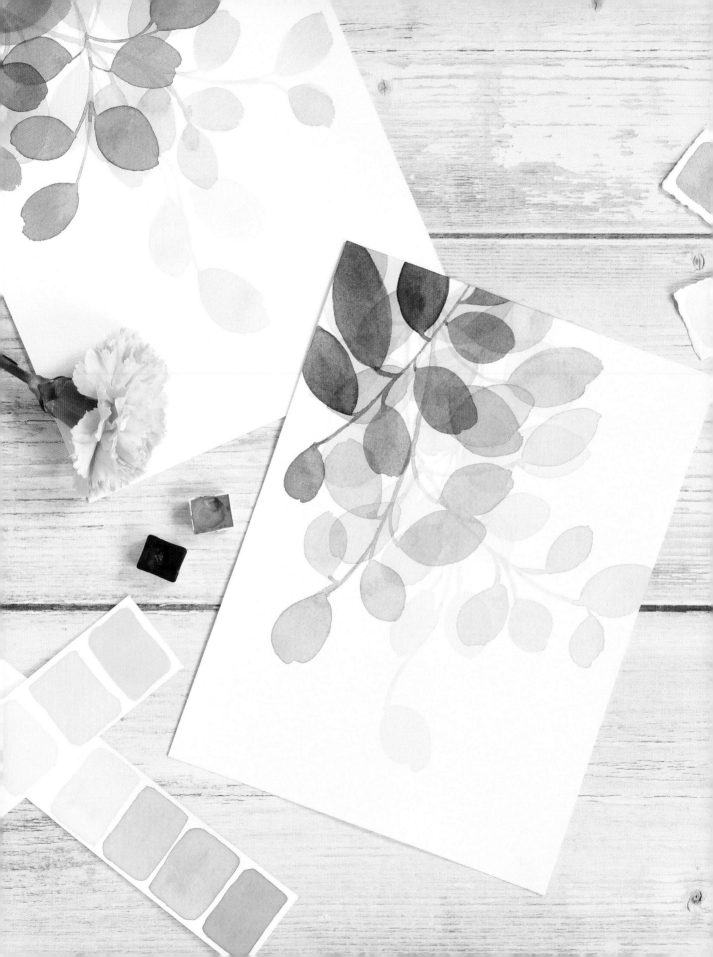

Draw the stem with a pencil, making a curved line. This will serve as a guide around which you will distribute the leaves.

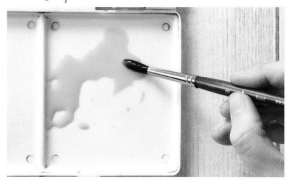

On your palette, dilute your yellow. It's important that this first color is very light. Prepare enough to paint the entire first coat.

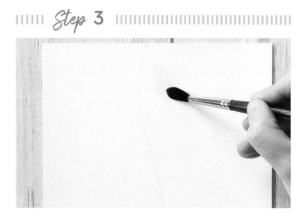

To paint a leaf, start with the tip of the brush. Then press more and more while making a rounded motion. This is the "tip-press" movement (page 17) that we saw in Tropical Plants, except that this time the motion is curved.

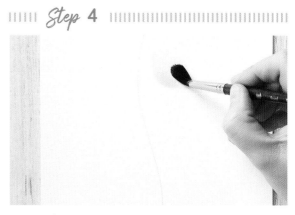

Repeat the same movement, starting at the tip of the leaf and curving in the opposite direction. You have just painted the first leaf!

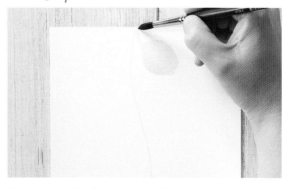

Next, paint a fine line that joins the stem.

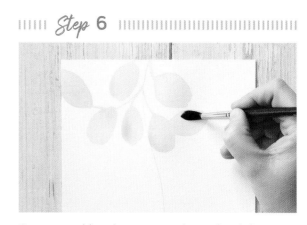

Continue adding leaves on either side of the stem, starting from the top.

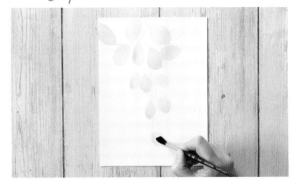

Keep adding leaves along the stem. Feel free to vary the size and orientation slightly.

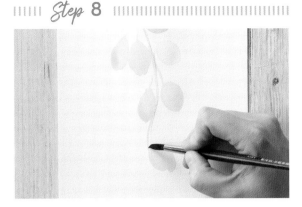

Finish by painting a thin line for the stem. Make sure each leaf is connected to it. Let dry completely before erasing the pencil.

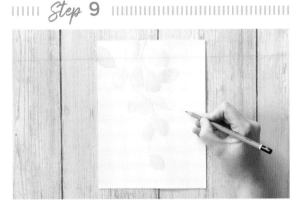

Draw a second stem with the pencil.

On the palette, add a little indigo to the yellow and dilute the resulting color. This green should be a little darker than the yellow used for the first coat, so it should be less diluted. Paint a leaf, starting on the left of the stem and working over the yellow.

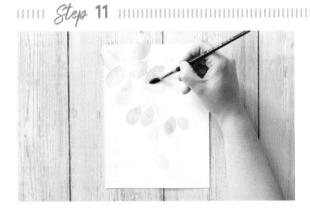

Continue to add leaves to the left and right of the stem; you should be able to see the leaves painted in the first layer due to the transparency.

Step 12

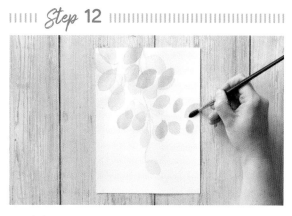

Finish by painting a leaf that goes beyond the edge of the paper.

Step 13

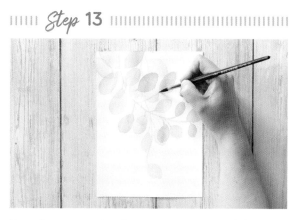

Paint the stem and make sure to connect each leaf to it. Let dry, then erase the pencil.

Step 14

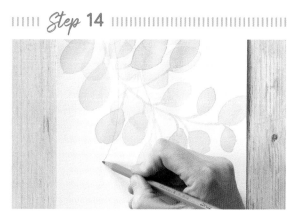

Draw a third stem with the pencil.

Step 15

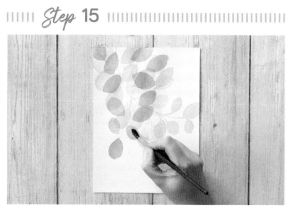

On your palette, add a little more indigo and dilute the green obtained even less than you did for the previous layer. Repeat the same process to paint leaves to the left and right of the stem, varying the orientation and size.

Step 16

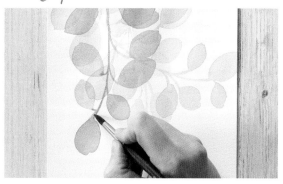

Add the stem and connect each leaf. Let dry completely, then erase.

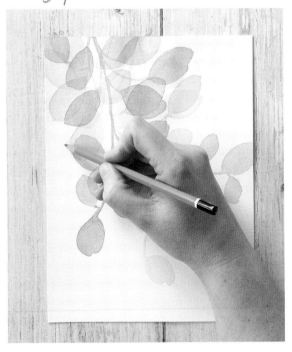

We're going to paint a final group of leaves. Draw the stem with the pencil.

On your palette, add a little more indigo to your mixture and dilute it slightly. The resulting green should be more indigo than yellow. Use this color to paint new leaves. Finish by painting the stem and then connecting each leaf. Let dry completely before erasing the pencil.

Tropical Landscape

The wet-on-wet technique involves applying wet paint to an already wet sheet of paper. It offers much less control, the pigments gradually diffusing to create a blurred result, which makes it perfect for painting cloudy skies but also abstract compositions. This technique is really fascinating because it encourages you to experiment and let yourself go!

Materials

- Greenish Umber
- Sap Green
- Hooker's Green
- Turquoise Green
- Pencil and eraser
- 300g/m², 100% cotton, cold-pressed watercolor paper
- Pointed round brush, medium size (size 8)
- Large wash brush (size 0)
- Painter's tape
- Some kind of support (cardboard or plastic)

Palette

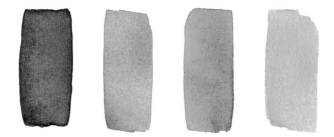

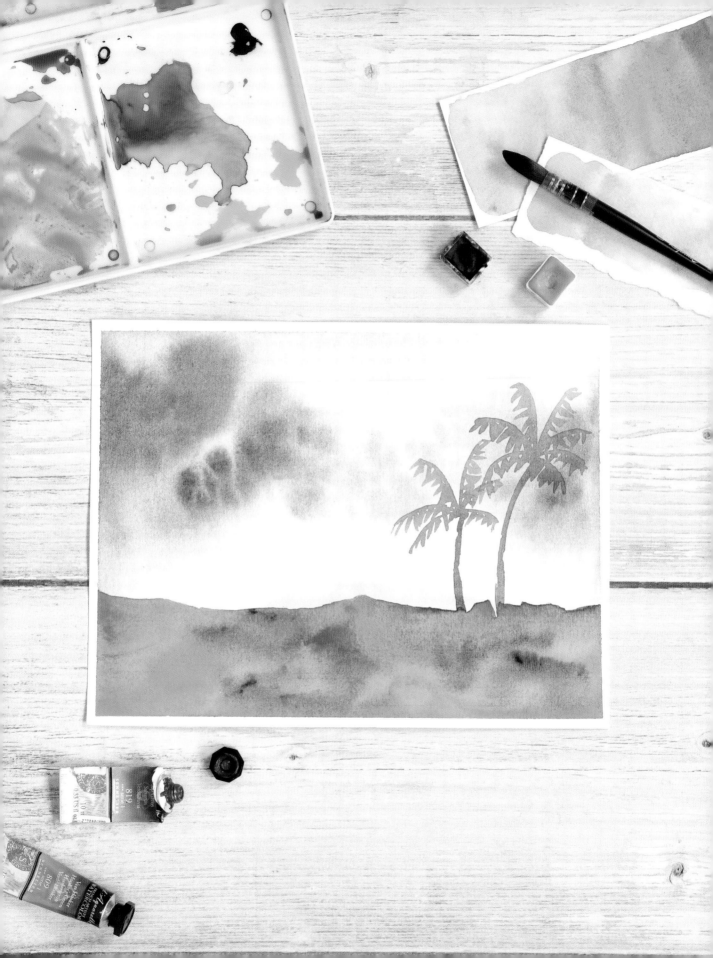

Step 1

If you are using a sheet of paper and not a block glued on all 4 sides, you must secure it on a support using painter's tape. This is to prevent the paper from curling too much from the water.

Step 2

With the large brush and perfectly clean water, start by wetting the top two-thirds of your paper in horizontal lines. You can draw the horizon line in pencil to serve as a guide.

Step 3

Repeat the same motion, this time making vertical lines. This is to ensure that the entire sheet is thoroughly wet. The paper should be moistened evenly; there shouldn't be any puddles.

Step 4

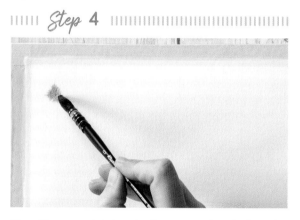

We will now paint the sky in one motion, before the wet area has time to dry. Still with the same brush and diluted Greenish Umber, place a point of pigment on your paper. This will instantly spread.

Step 5

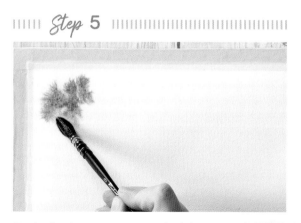

Gradually place new spots on the left, spacing them out to leave room for the paint to diffuse.

Step 6

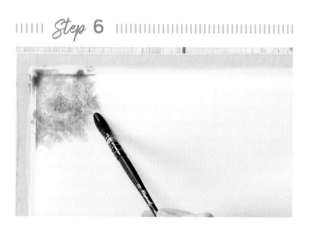

Continue until you have covered the top left corner of the paper.

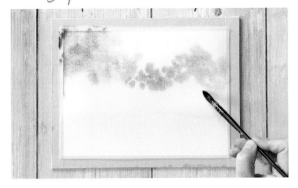

Refill your brush whenever you feel it's getting too dry; it should stay quite wet. Continue to add small dots to form an arc of a circle until you reach the right edge of the paper.

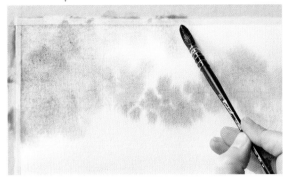

Enlarge the cloud on the left, still using small dots.

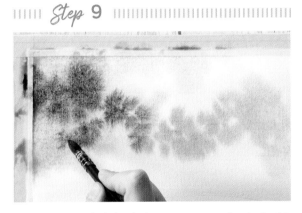

Now using a slightly darker gray, more loaded with pigment, place new drops in the middle of the cloud on the left.

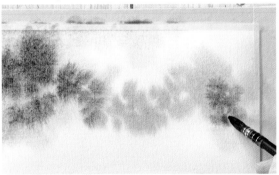

Repeat the same process with the cloud to the right, without touching the central part. The goal is to create clouds of different densities to add depth to the sky.

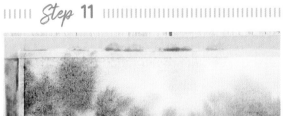
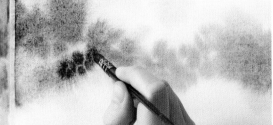

With an even darker gray, place a few more drops on the left cloud, in smaller quantities than in the previous step.

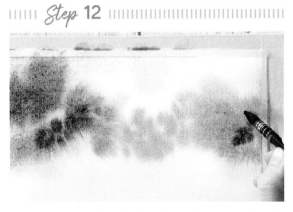

Do the same on the cloud to the right; you really only need to add a few drops to darken a small area.

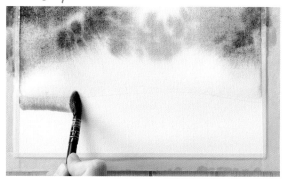

Without giving the sky time to dry, paint a line with Sap Green at the very bottom of the wet area. The paint will diffuse slightly on contact with the water.

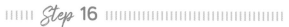

Using a back-and-forth motion, fill the entire bottom of the paper with this green. Let dry completely.

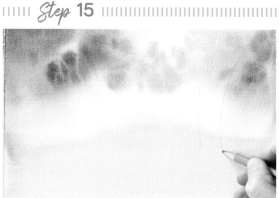

With a pencil, draw 2 lines about a third of the way from the right edge of the paper. They will serve as your guide when painting the palm trees.

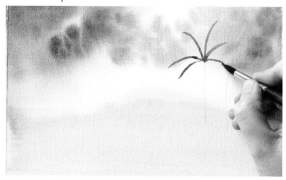

Using the pointed round brush and a mixture of Hooker's Green and Greenish Umber, paint thin curved lines starting from the top of the trunk to create the palm frond stems.

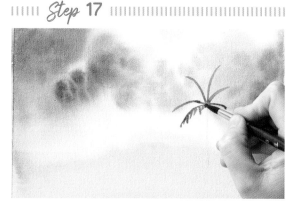

Still with the same color, add small lines that start from the lowest stem, painting them in different directions so as to add some movement.

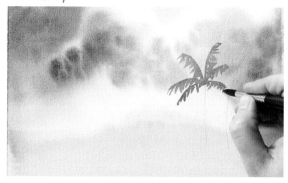

Add lines below each stem using the same process.

Step 19

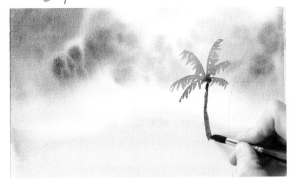

Paint the trunk by creating a line that is narrower at the top and wider at the base.

Step 20

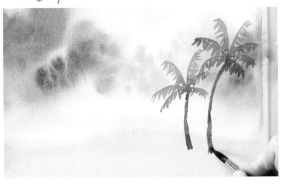

Add a second palm tree by repeating the exact same steps.

Step 21

With Sap Green, paint an irregular line at the base of the palm trees. You must paint it immediately, while the trunks are still wet.

Step 22

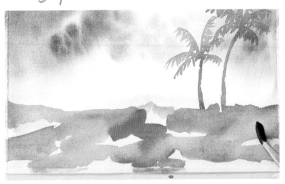

Continue to fill the bottom of the paper in this way; don't cover the whole area but leave empty spaces here and there.

Step 23

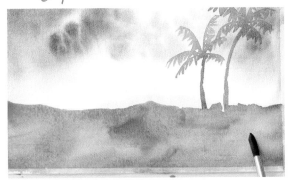

With a mixture of turquoise and Hooker's Green, fill in the empty spaces.

Step 24

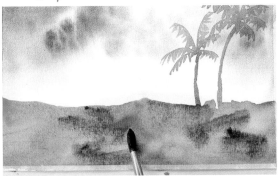

Finish with slightly diluted Greenish Umber, adding a few lines under the palm trees and in the middle to create shadows. As the hill is still wet, the paint will diffuse slightly. Let dry completely before removing the tape.

Flowers

Techniques

Blending two colors
Blending color
and water

When two wet colors come into contact, or when a wet color meets a wet area, the paint diffuses and merges to create a new color. It really is one of the most magical aspects of watercolor; working in the wet always produces great surprises. The result is not immediately visible; the colors must be allowed time to diffuse.

Materials

- Rose Madder Lake
- Naples Yellow
- Chromium Oxide Green
- 300g/m², 100% cotton, cold-pressed watercolor paper
- Pointed round brush, medium size (size 8)
- A second cup of clean water

Palette

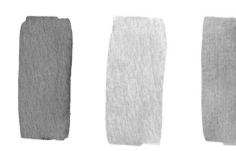

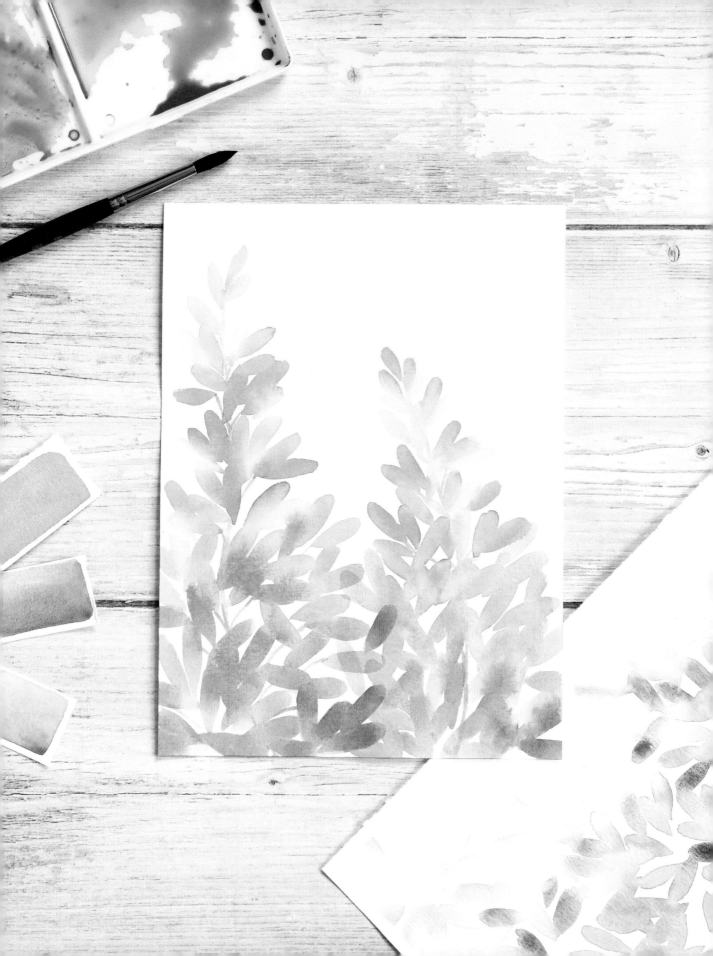

On the palette, prepare a mixture of rose and yellow in sufficient quantity to be able to paint the 2 flowers; dilute your green as well. The goal is to have your colors ready before you start so you can work quickly while the paint remains wet.

We're going to use the same brushstroke to create each petal. Start by resting the tip of the brush on the paper.

Now press the head of the brush in a slight lateral movement to form a rounded end.

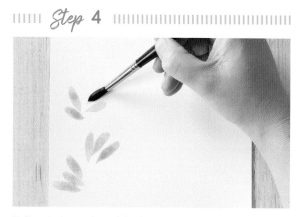

Still with this color, add other petals, repeating the same movement each time. Vary the orientation of the petals and distribute them around an imaginary axis.

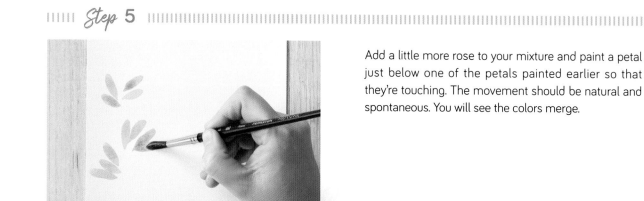

Add a little more rose to your mixture and paint a petal just below one of the petals painted earlier so that they're touching. The movement should be natural and spontaneous. You will see the colors merge.

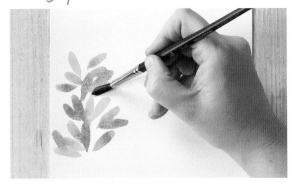

Continue to add more petals in this way, focusing on the same area, the goal being that the colors always stay wet.

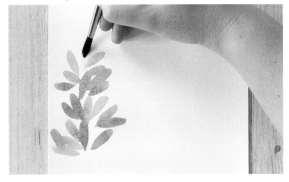

Rinse your brush. Using the clean water from your second pot, paint a petal on the upper part, touching a pink petal. The paint will diffuse very slowly in the water.

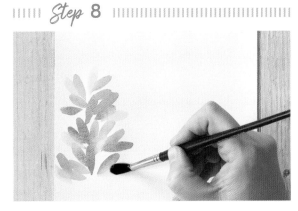

Add other petals with water using this same process, always on the same area, rinsing your brush well each time.

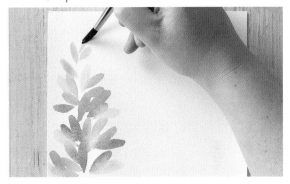

Use a lighter pink to paint a few smaller, further-spaced petals at the top of the flower.

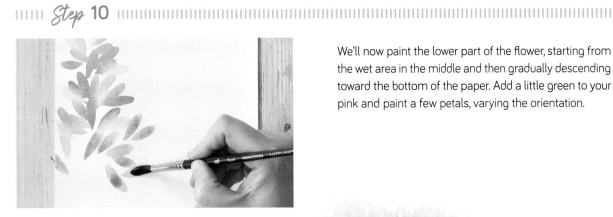

We'll now paint the lower part of the flower, starting from the wet area in the middle and then gradually descending toward the bottom of the paper. Add a little green to your pink and paint a few petals, varying the orientation.

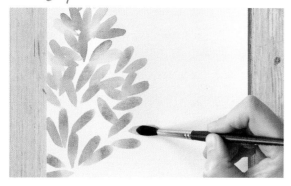

Add a little more green to your mixture and continue painting petals.

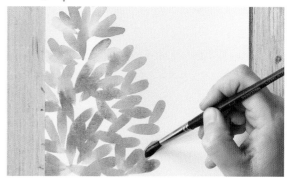

Finish by using only green and making the lower part denser.

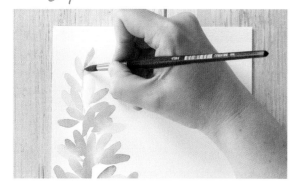

Still with this same green, paint the stem by making a line from the bottom of the paper to join the last petal at the very top.

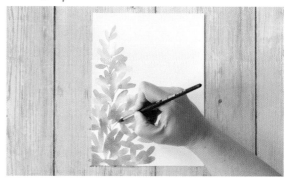

Add a few stems here and there to give the impression that the petals are connected to the stem. This first flower is now complete!

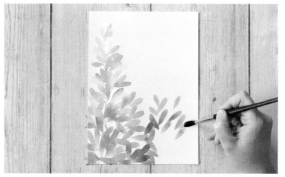

We are now going to paint a second flower on the right using the same process and, above all, without letting it dry. With the rose and yellow mixture, paint a series of petals, this time starting with the area in contact with the first flower.

Step 16

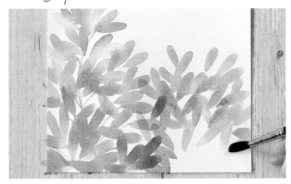

Continue to paint petals on the lower part, gradually adding green to your mixture.

Step 17

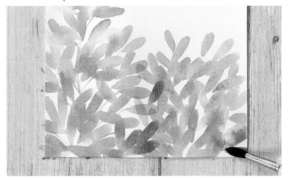

Finish by using pure green.

Step 18

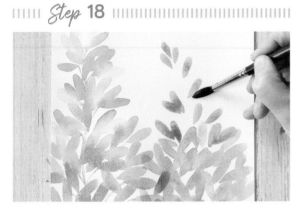

Now paint the top of the flower with rose.

Step 19

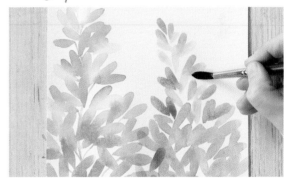

Use clean water to paint a few final petals.

Step 20

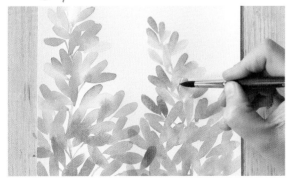

Finish with the central stem, and add a few secondary stems.

Seascape

Technique

Reserve technique:
The white of the
paper

In watercolor, there is no such thing as white; we simply use the white of the paper. This means that you cannot add this color after painting, but on the contrary, you have to remember to reserve white areas on the paper. There are different methods of doing this, the first being to intentionally leave spaces blank by avoiding painting them. A seascape lends itself perfectly to this exercise. Instead of painting the light on the water and the foam, we will go around these areas so that the white of the paper remains clearly visible. This technique lends itself to all subjects and requires just a little forethought. For example, you can use it for the veins of a leaf or a snowy landscape.

Materials

- Phthalocyanine Blue
- Hooker's Green
- Sap Green
- Naples Yellow
- French Vermilion
- Pencil
- Square 300g/m², 100% cotton, cold-pressed watercolor paper
- Pointed round brush, medium size (size 8)
- Large wash brush (size 0)
- Painter's tape
- Some kind of support (cardboard or plastic)
- A second cup of clean water

Palette

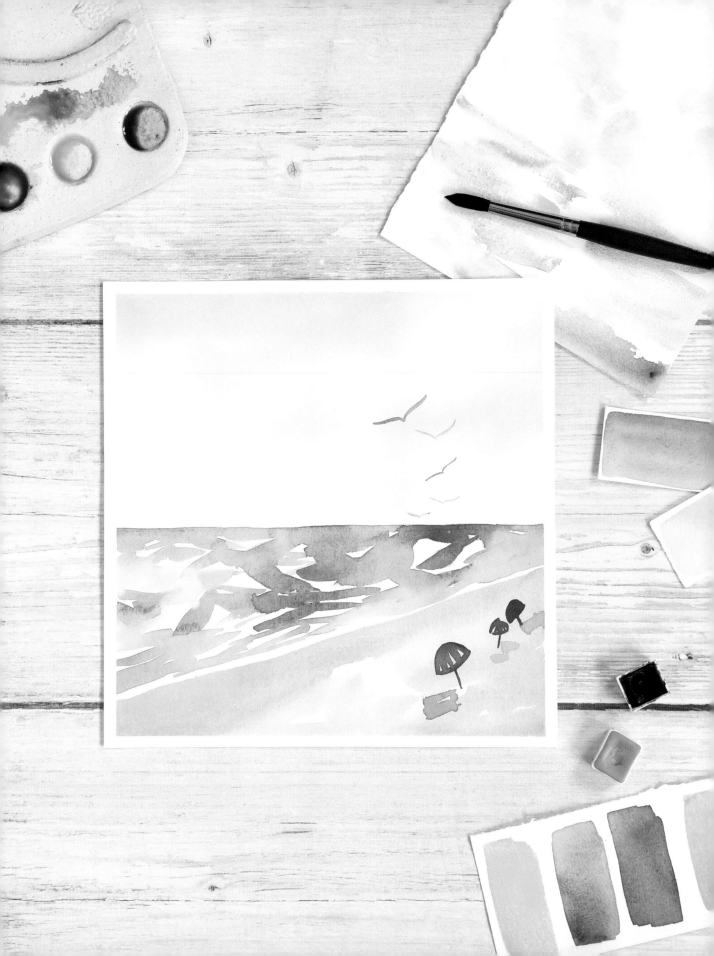

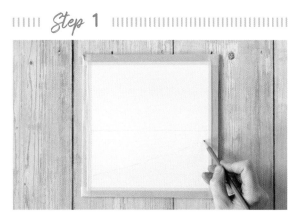

Tape your sheet of paper to the support, then draw 2 lines in pencil to be your guides when painting this landscape.

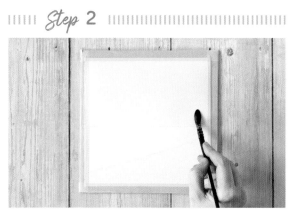

Using your large brush and perfectly clean water, wet the sky area.

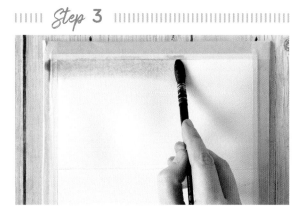

On the palette, mix the blue with Hooker's Green to get a turquoise, and prepare enough of this color to be able to paint the sky and the sea. Load the large brush well with pigment and paint a line at the top of the sky.

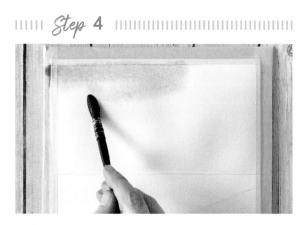

Without lifting your brush, continue this movement by painting a line diagonally downward.

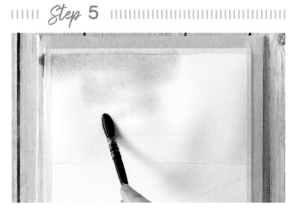

Continue this zigzag movement, never lifting your brush.

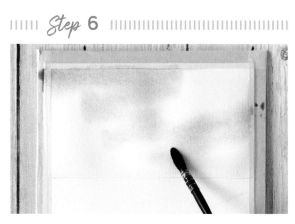

Stop when you have reached the bottom of the wet area. The goal is not to cover the whole sky with this blue but to leave some white areas. As the paper is wet, the paint will diffuse and occupy a larger area than expected. Let dry completely.

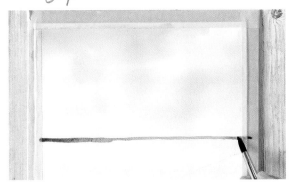

With your pointed round brush and still with the turquoise, paint the horizon line.

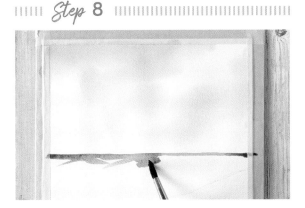

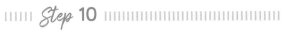

Still with the tip, add small lines starting from the horizon line to create waves. Intentionally leave white spaces.

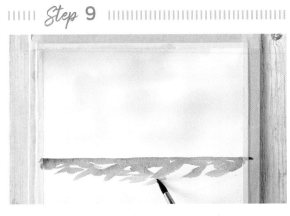

Continue to add lines in this way, varying the orientation and the pressure on the brush in order to obtain different thicknesses.

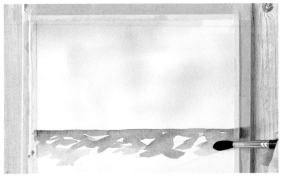

Repeat the process, this time with very clean water.

Continue, but this time with darker turquoise. The goal is to use the blending so that the color of the sea is not uniform. Remember to leave white areas here and there.

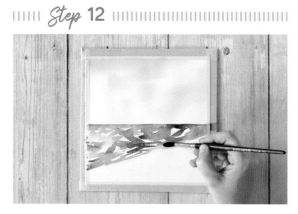

Finish by using the same process until you reach the pencil line.

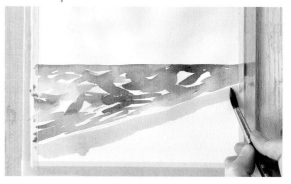

With a mixture of red and yellow, paint a line parallel to the seashore. Do not put it right up next to the blue, but instead leave a white space between these 2 areas to represent the foam.

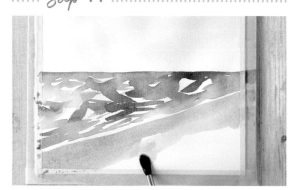

Continue to paint the sand, alternating lines with this mixture and lines with water, as you did for the sea. Be sure to leave some white areas.

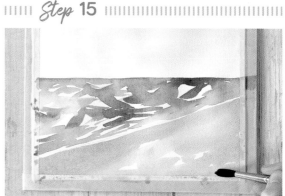

Paint the entire bottom area in this way and then let dry completely.

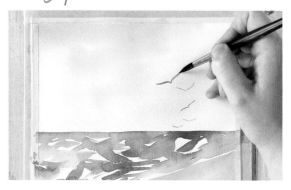

Again with the turquoise and using only the tip of the brush, add birds in the sky. To do this, create a slightly rounded V shape. Vary the size and orientation of the birds so they don't look frozen in space.

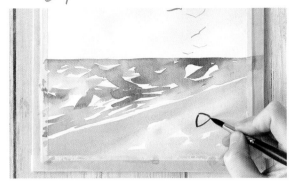

We will now add the beach umbrellas. Start by painting the outline with red.

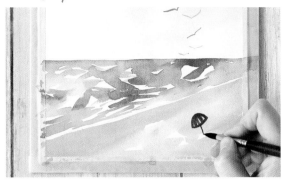

Add stripes as well as the base of the umbrella, always using the tip of the brush.

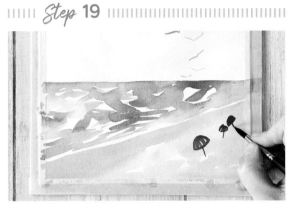

Paint 2 smaller umbrellas on the right using the same process.

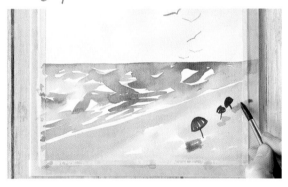

Add a touch of Sap Green to your orange and paint a few rectangles for beach towels. And this seascape is finished!

Mushrooms

Technique

—

Creating textures

Working in the wet, you're able to create a variety of textures using materials you already have around the house. This is another very fun aspect of watercolor as it invites you to experiment. Mushrooms lend themselves perfectly to this exercise, but you can use these textures for many other subjects: creating a background for a landscape, adding relief to a tree trunk or berries, achieving a more dynamic final product … The possibilities are endless! The effect is not necessarily visible right away but grows as your work dries. So you have to be a little patient.

Materials

- Naples Yellow
- French Vermilion
- Sap Green
- Pencil and eraser
- Square 300g/m²,
 100% cotton, cold-pressed
 watercolor paper
- Pointed round brush,
 medium size (size 8)
- Cotton swab
- 90% rubbing alcohol
- White ink
- A second cup of clean water

Palette

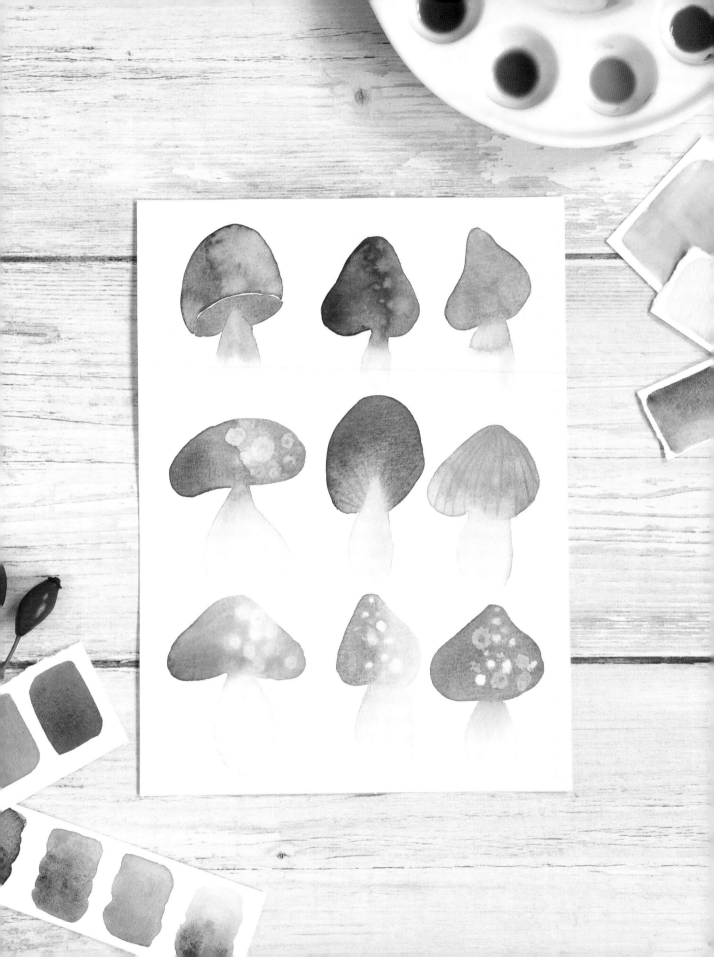

Draw the silhouette of the mushrooms with a pencil.

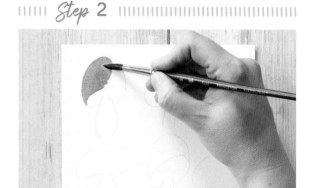

On your palette, mix red with green to get a brown. Paint half the cap of the first mushroom with this color in a thin layer.

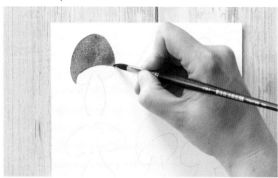

Add a little more red to your brown and finish painting the cap.

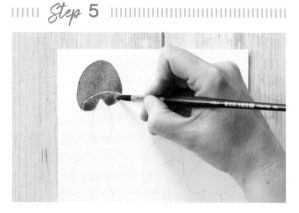

This time add a little more green to your brown and paint a line under the cap, leaving some white space.

Finish by filling this area with the same color..

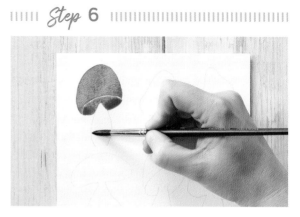

Using the clean water from your second cup, wet the stem of the mushroom, starting from the bottom.

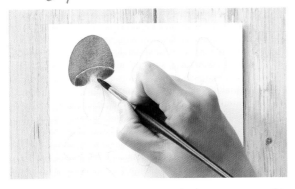

Continue to wet the stem from the bottom up until it touches the brown area; this will allow the color to diffuse into the wet area.

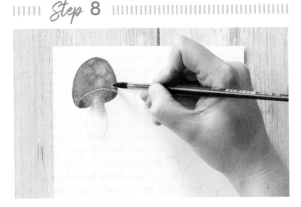

Without letting it dry, drop a few drops of clean water on the cap using the tip of the brush. As it diffuses, the water will create halos.

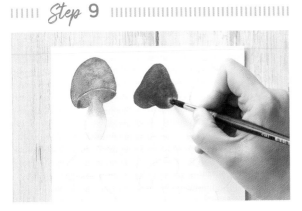

Let's move on to the second mushroom! Paint the cap half red, half brown.

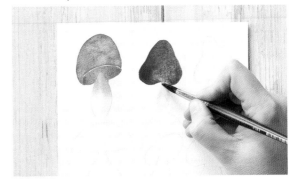

In the same way as before, first wet the bottom of the mushroom stem, then move upward until the water comes into contact with the cap. All the mushroom stems will be painted in this way.

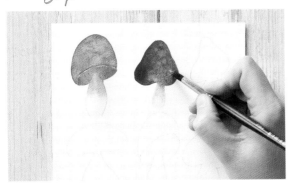

Using the tip of the brush, add a few drops of highly pigmented yellow to the cap. The drops remain small and will barely diffuse since the paint is not very diluted.

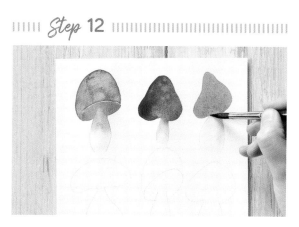

Paint the cap of the third mushroom green and wet the stem in the same way as before.

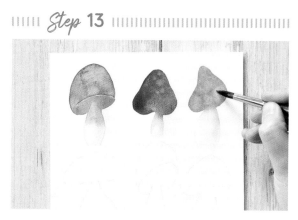

Add a few drops of very diluted yellow this time; the paint will diffuse more widely than on the previous mushroom.

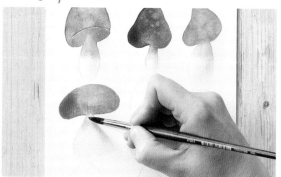

Paint the cap of the fourth mushroom by combining brown and green, then wet the stem.

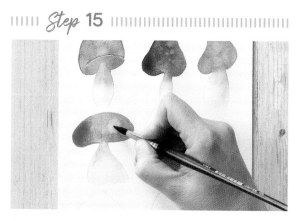

With the tip of the brush, apply a drop of rubbing alcohol, which will repel the paint while creating a distinct texture.

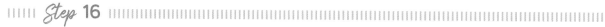

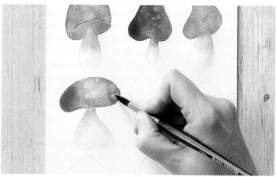

Add several more drops in varying sizes. Rinse your brush well when you're done.

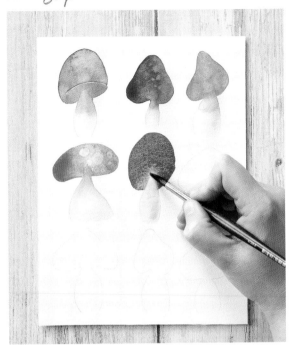

Let's move on to the next mushroom! Paint the top of the cap red and the underside brown, then wet the stem.

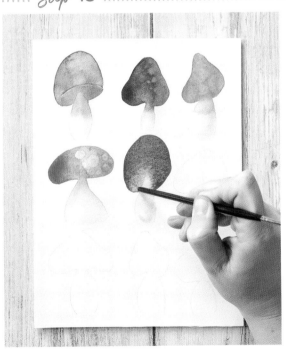

With the end of the brush handle, etch a line in the still damp brown paint. As the paint will build up here, this line will appear darker. The effect is not instantaneous and increases with drying. The thickness of the line will depend on the size of the brush handle.

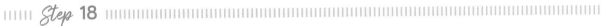

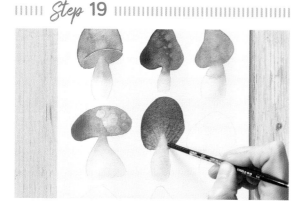

Using the same process, add other lines so as to represent the gills of the mushroom.

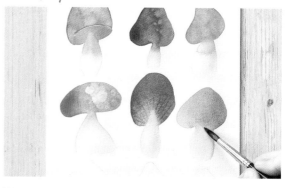

We are now going to combine 2 textures on the same mushroom. Paint the cap of the next mushroom half green, half brown, then wet the stem.

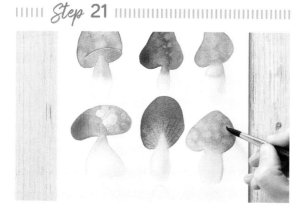

Using the tip of the brush, place a few drops of water on the cap.

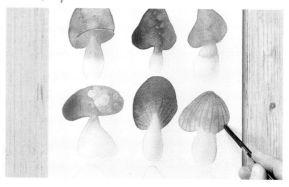

Next use the end of the handle to create stripes on the cap.

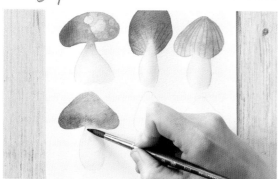

Now let's paint the next mushroom! Use yellow and red for the cap and then wet the stem.

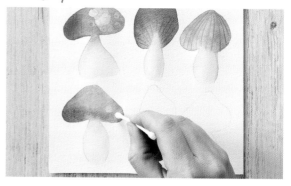

Press the end of a cotton swab firmly onto the cap. The goal is to use it to remove paint and create a round shape. Don't hesitate to press firmly and spin the cotton swab in place.

Step 25

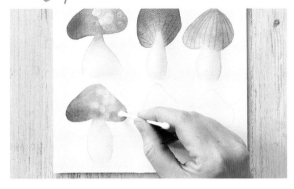

Repeat the process several times to create several circles. If the tip of the cotton swab gets too dirty, turn it over to use the other end.

Step 26

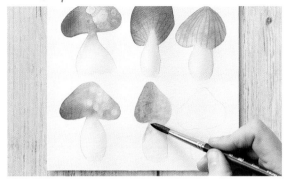

Fill the cap of the next mushroom with yellow and green, then wet the stem.

Step 27

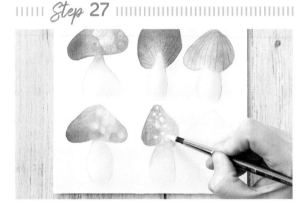

Place a few drops of white ink on the cap with the tip of the brush. The ink will repel the paint while diffusing.

Step 28

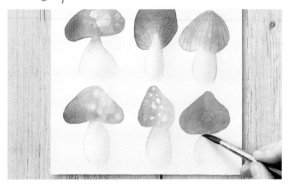

To finish, we're going to combine the rubbing alcohol with the ink. Paint the cap of the last mushroom green, then wet the stem.

Step 29

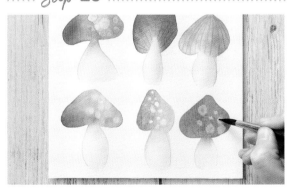

Add a few drops of rubbing alcohol to the cap.

Step 30

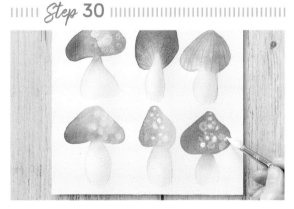

Finish with a few drops of white ink. Let dry completely before erasing the pencil.

Botanical Greenhouse

Drawing gum or masking fluid is a thick liquid that helps protect the white of the paper by preventing the paint from adhering. It is applied with a brush before painting and is removed last. Its sticky texture tends to damage a brush very quickly, and I advise you to use it with a low-end brush reserved specifically for this use. If you bought a watercolor palette that comes with a brush, you can use this one.

Materials

- Rose Madder Lake
- Naples Yellow
- Brown Green
- Sap Green
- Hooker's Green
- Phthalocyanine Blue
- Pencil and eraser
- 300g/m², 100% cotton, cold-pressed watercolor paper
- Pointed round brush, medium size (size 8)
- Large wash brush (size 0)
- Fine brush for drawing gum
- Drawing gum
- Dishwashing soap
- Painter's tape
- Some kind of support (cardboard or plastic)
- A second cup of clean water

Palette

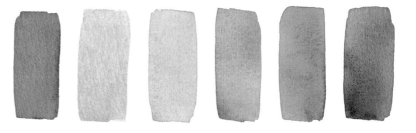

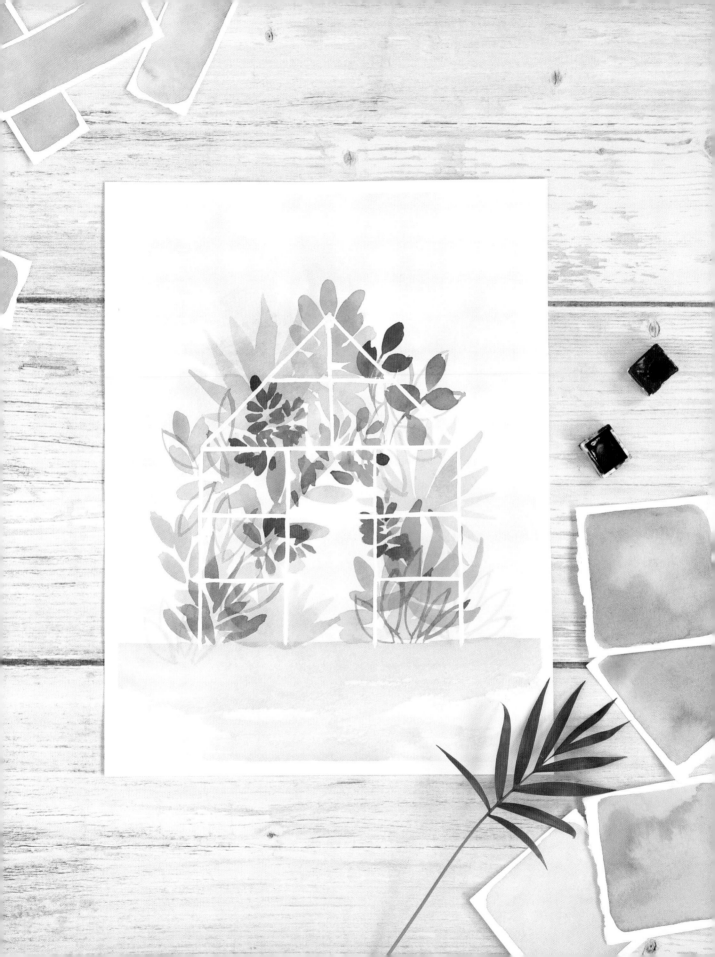

Tape your paper onto a support, then draw the green-house with a pencil.

Put a few drops of dishwashing soap on your palette, then dip your brush in it; the bristles should be well coated. Dishwashing soap will protect your brush.

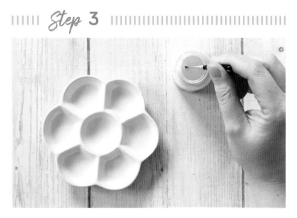

Next dip your brush directly into the jar of drawing gum.

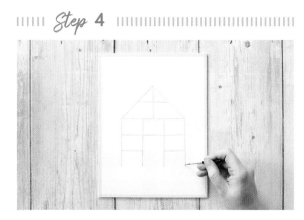

Going over the pencil drawing, paint the silhouette of the greenhouse with drawing gum and let dry. Immediately rinse your brush thoroughly under a tap. The gum absolutely must not dry on the brush, or it may permanently damage it.

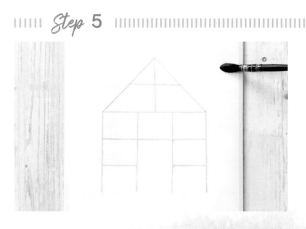

Using your large brush and perfectly clean water, wet the entire sheet, passing over the drawing gum.

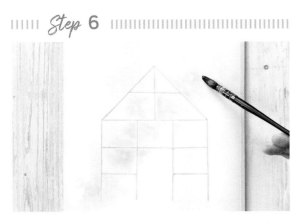

On your palette, mix rose with Naples Yellow. Place drops of this color on your paper, forming a diagonal.

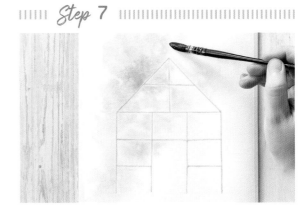

On your palette, mix Sap Green with yellow and place drops of this color above the pink area.

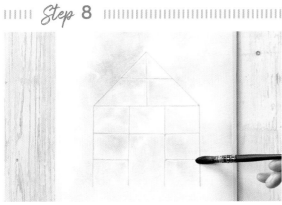

Do the same thing below the pink area. There's no need to overdo it; the goal is to create a light background.

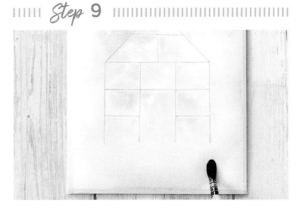

Finish by painting horizontal lines under the greenhouse, still with the same color. Let dry completely.

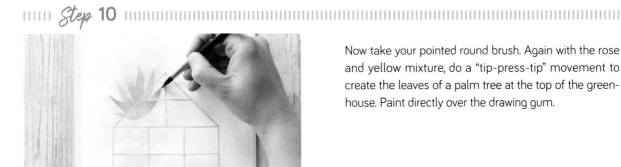

Now take your pointed round brush. Again with the rose and yellow mixture, do a "tip-press-tip" movement to create the leaves of a palm tree at the top of the greenhouse. Paint directly over the drawing gum.

Step 11

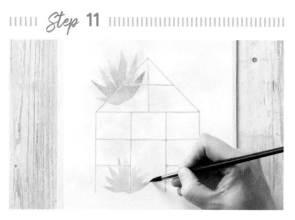

In the same way, add a palm tree at the very bottom.

Step 12

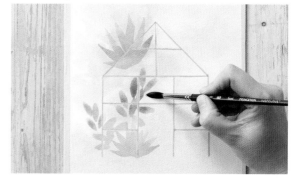

Now use a "tip-press" movement to create 2 bushes of leaves at the bottom of the greenhouse, still with the pink.

Step 13

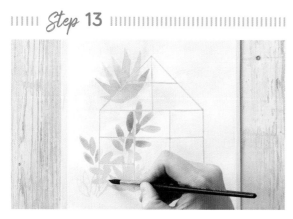

Paint the silhouette of a palm tree using only the tip of the brush.

Step 14

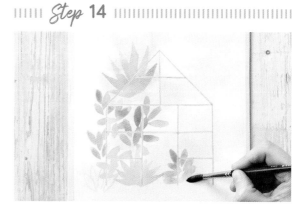

With Brown Green, paint 2 leafy bushes with the "tip-press" movement.

Step 15

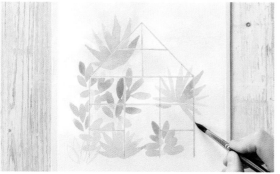

Add a palm tree at the top right, still with the same green.

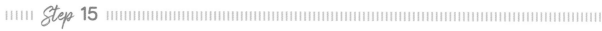

Step 16

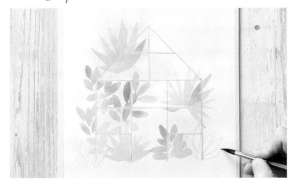

Finish with a few silhouettes of palm fronds at the bottom of the greenhouse.

Step 17

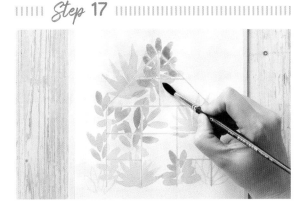

With a mixture of Sap Green and blue, paint a cluster of leaves at the very top.

Step 18

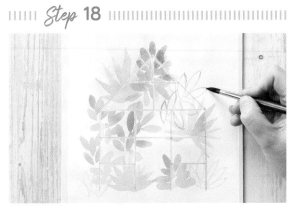

Add a few leaves, painting only the outline this time. The goal is to gradually fill the interior of the greenhouse.

Step 19

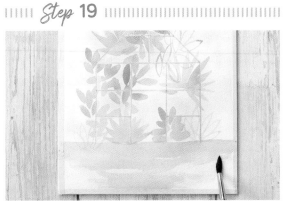

Finally, with a mixture of rose and yellow, paint the soil under the greenhouse by making horizontal lines. Don't overload your brush with pigment so that you will obtain a slightly dry texture. Let this layer dry completely.

Step 20

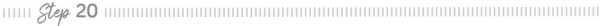

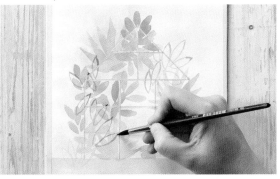

We will now continue to layer different plants, alternating full and empty shapes to give contrast. With Hooker's Green, paint the outline of a few leaves, varying the orientation.

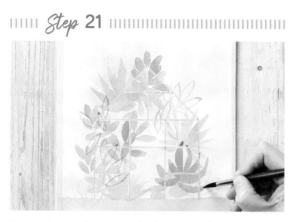

Next paint a palm tree at the bottom of the greenhouse. Use the "tip-press-tip" movement, this time making curved lines.

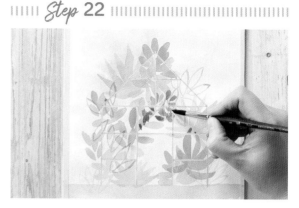

Now add a group of smaller leaves, this time using the "tip-press" movement.

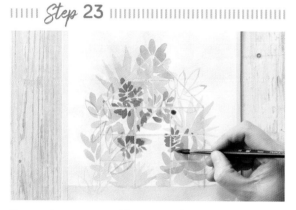

Paint other groups of leaves in the same way with a slightly diluted Sap Green.

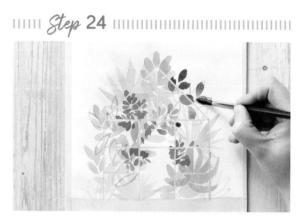

Mix a little blue with Sap Green to get a darker shade; this will add contrast. Paint 2 groups of leaves close together at the top right of the greenhouse.

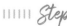
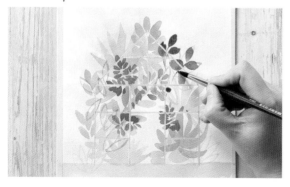

Next use the tip of your brush to paint 2 stems and connect the leaves.

Step 26

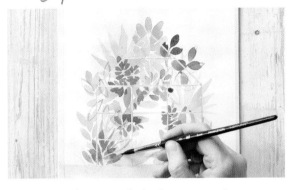

Add a new palm tree with the "tip-press-tip" movement to the base of the greenhouse so that it looks as though it starts from the ground.

Step 27

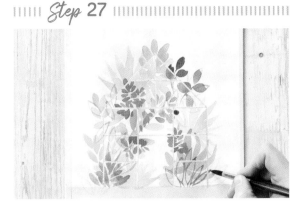

Finish by adding a last group of leaves on the right side, this time painting only the outline. Let dry completely.

Step 28

To remove the drawing gum, rub at the base of a line with your finger to loosen it. Make sure you have clean hands so that you don't leave any marks on the paper.

Step 29

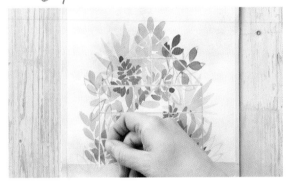

Now pick up the end and pull gently.

Step 30

Gradually remove all of the drawing gum to reveal the entire greenhouse, then erase the pencil.

Berries

Technique

—

Blurring a sharp edge

By using water to your advantage, you can create all kinds of effects, including blurring a sharp edge. This makes it possible to soften the outline of a subject but also to add depth. You can use this technique whenever you want to achieve a blurred, soft-focus result, regardless of the subject of your watercolor. When used with a superposition of layers, you will obtain an effect of accumulation that can be very useful, particularly for painting plant life.

Materials

- Rose Madder Lake
- Naples Yellow
- Pencil and eraser
- Square 300g/m²,
 100% cotton, cold-pressed
 watercolor paper
- Pointed round brush,
 medium size (size 8)
- Fine brush (size 2)
- Fine brush for drawing gum
- Drawing gum
- Cotton swab
- Painter's tape
- Some kind of support
 (cardboard or plastic)
- A second cup of clean water

Palette

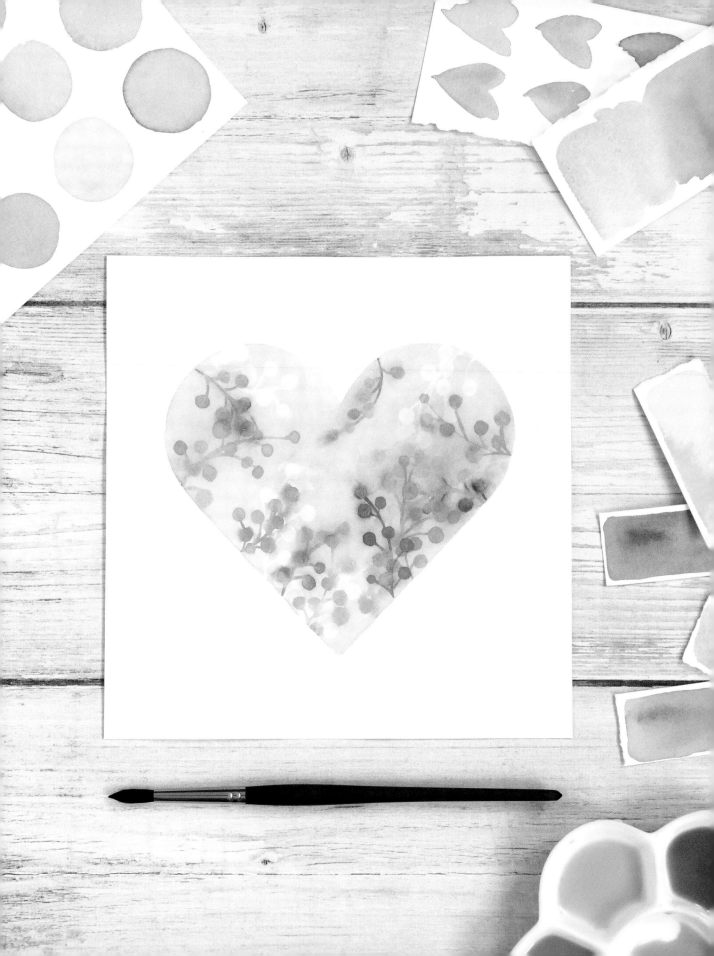

Tape your sheet of paper onto a support, then draw the silhouette of a heart with pencil.

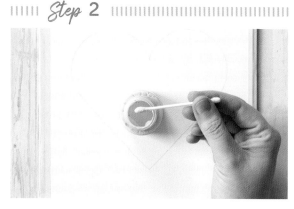

Dip the tip of a cotton swab into the drawing gum.

Press your cotton swab onto the paper so as to create a round imprint. Add other small circles close to each other to form a cluster.

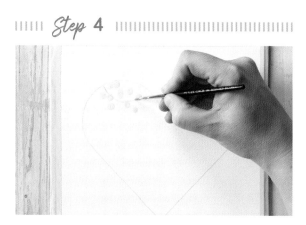

With your brush, paint a thin line starting from the edge of the heart to the furthest berry.

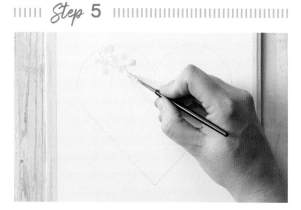

Connect each berry to the main stem.

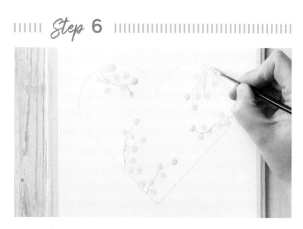

Using the same process, add other bunches all around the heart. Let the drawing gum dry completely.

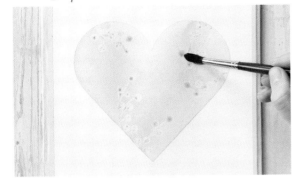

On your palette, mix the rose with a tiny bit of yellow and dilute the resulting color. With a medium brush, paint the entire heart, passing over the drawing gum. Let dry again.

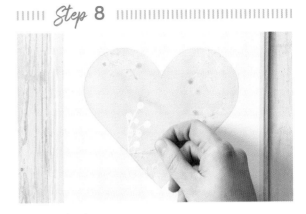

Remove the drawing gum.

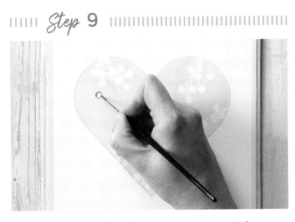

With your fine brush and some rose, paint a circle.

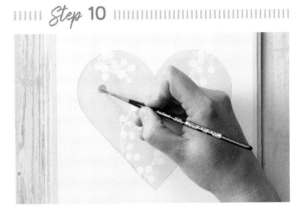

Fill this circle with a thin layer.

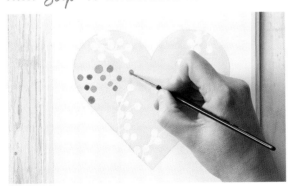

Paint other circles in the same way so as to form a cluster of berries.

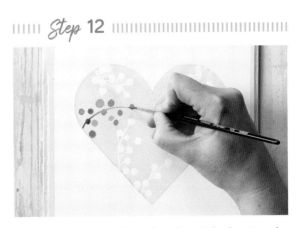

Paint the main stem from the edge of the heart to the furthest berry.

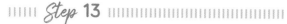
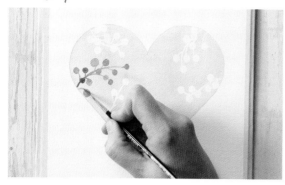

Connect each berry to the main stem.

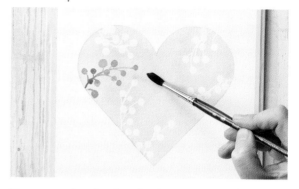

Dip your medium brush in the clean water from the second cup and wring it out well. It should be wet but not sopping. Wet an area about 2cm (³⁄₄in) wide around the cluster of berries, being careful to not touch the wet paint.

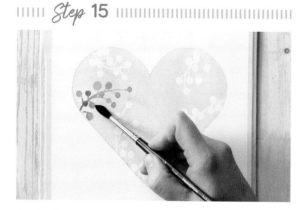

Gradually move in to touch the berries one by one with your brush. When the paint has been applied in a thin layer as it is here, it creates a slightly blurred effect. Continue to wet the outline of each berry as well as the stem, following the same process. This first cluster is finished!

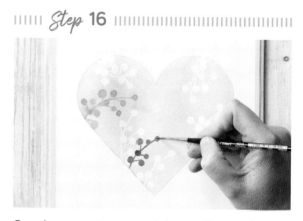
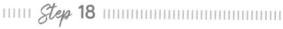

On a dry area, paint a second cluster of berries, this time using a more saturated rose and making a thicker coat.

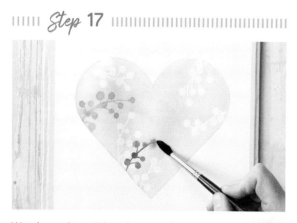

Wet the outline of this cluster in the same way as before, then touch each berry with your wet brush. The paint diffuses this time in the water in a more noticeable way, making the outline of the berries very blurry.

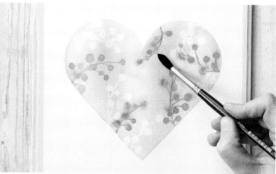

Using the same process, add more bunches of berries. Be sure to paint wherever your paper is dry. When you have gone completely around the heart, let dry completely.

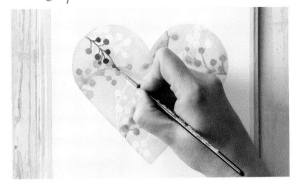

Starting from the top of the heart again, add a new cluster of berries using a more saturated rose. Don't hesitate to paint these berries over those painted earlier.

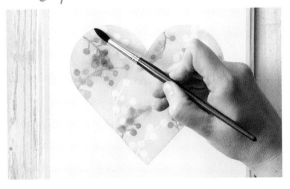

Wet the outline of the bunch always with the same technique, starting from the outside and then coming into contact with the berries. Be careful to add water up to the outer edge of the heart so that the silhouette is clear.

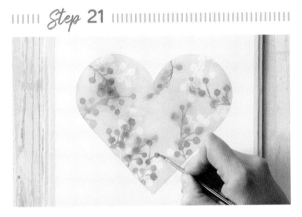

Using this process, create other bunches of berries, gradually adding yellow to your rose. Be sure to start each time on a dry area.

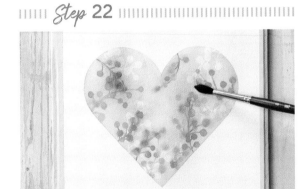

Finish with 2 very yellow clusters. Let dry completely.

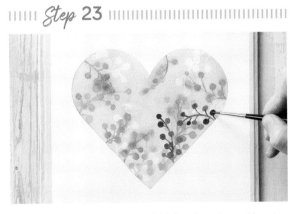

With a very saturated rose, add 2 last bunches of berries.

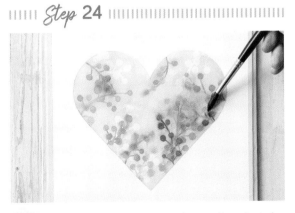

Using the same process, wet the outline. Let dry completely before erasing the pencil.

Meadow in Bloom

Salt is a very easy way to create an original texture. It is always applied last, while your work is still wet, before letting the paint dry. The result is not instantly visible; you have to wait while the salt absorbs the pigments and creates white starlike marks. The effect will be more or less noticeable depending on whether the color is light or dark. Salt is an asset for adding relief, especially for marine subjects, but also winter landscapes or even plants.

Materials

- Sap Green
- Brown Green
- Turquoise Green
- Rose Madder Lake
- 300g/m², 100% cotton, cold-pressed watercolor paper
- Pointed round brush, medium size (size 8)
- Large wash brush (size 0)
- Table salt
- Painter's tape
- Some kind of support (cardboard or plastic)

Palette

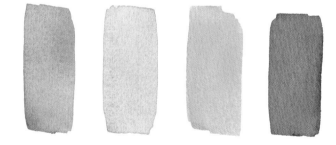

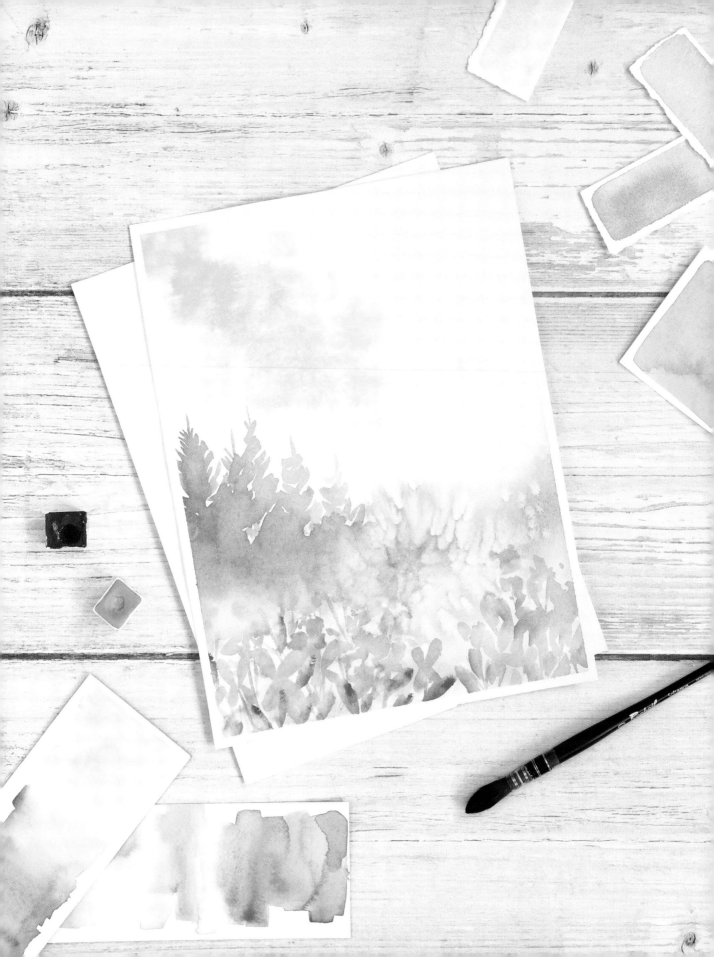

Tape your paper to the support, then wet it completely with a large brush and perfectly clean water. We'll use the wet-on-wet technique to paint the entire first coat before the paper begins to dry.

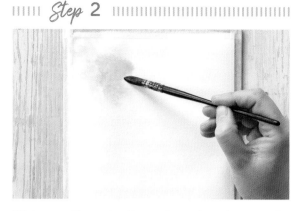

Dilute your Turquoise Green, then place drops on the paper starting from the upper left corner.

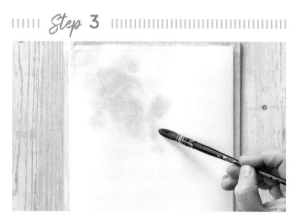

Continue to apply drops of turquoise in a diagonal.

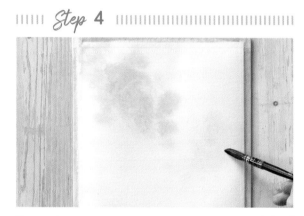

Repeat the same process so as to create a second cloud on the right.

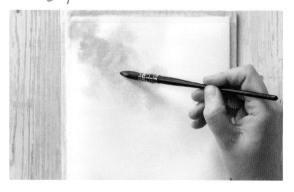

Place a few drops on the first cloud again, this time using a more saturated turquoise.

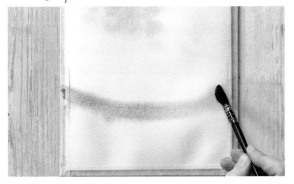

Paint a curved line with Sap Green to represent the horizon line.

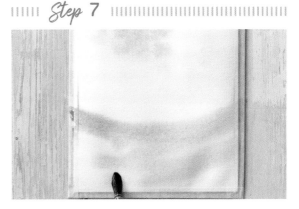

Without lifting your brush, move back and forth until you reach the bottom of the paper.

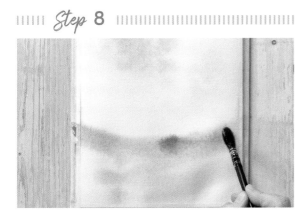

With Brown Green, paint another curved line, this time starting from the middle of the horizon line.

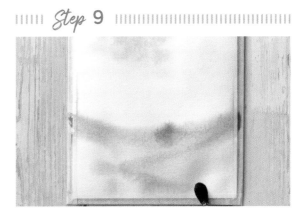

Without lifting your brush, move back and forth, spacing your lines a little further apart than before.

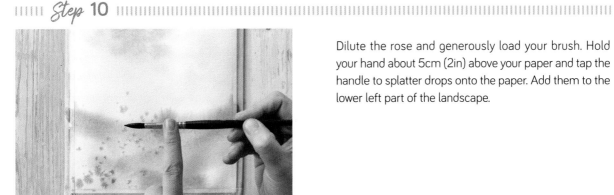

Dilute the rose and generously load your brush. Hold your hand about 5cm (2in) above your paper and tap the handle to splatter drops onto the paper. Add them to the lower left part of the landscape.

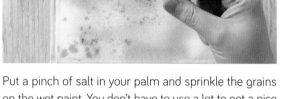

Put a pinch of salt in your palm and sprinkle the grains on the wet paint. You don't have to use a lot to get a nice result. Let dry completely. Do not speed up the drying with a hair dryer, as this will also stop the effect of the salt.

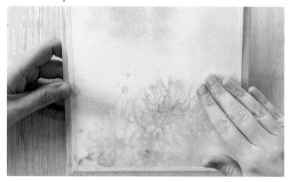

Remove the grains of salt by rubbing gently with your fingertips. Make sure to remove all of it.

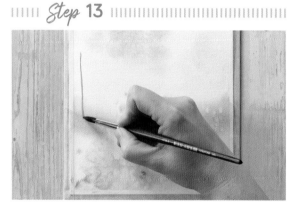

We will now paint some trees. Mix Sap Green with Brown Green. With your pointed round brush, draw a thin line for the trunk.

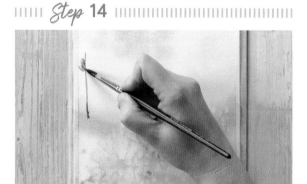

Start painting the foliage on the left side of the trunk. Make small lines going from the outside in.

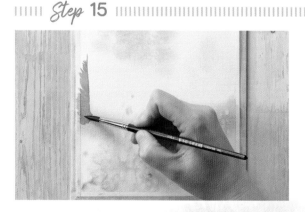

Continue painting the foliage, adding longer and longer lines. Imagine the shape of a triangle, narrow at the top and wide at the base.

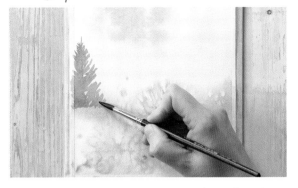

Repeat the same process to paint the right side of the tree.

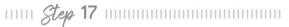
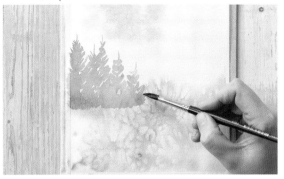

Add 3 more trees in this way, varying the height of the trunks.

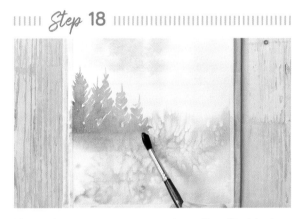

Using clean water, wet a strip about 5cm (2in) high at the base of the trees. This allows you to have no line of separation between the trees and the meadow.

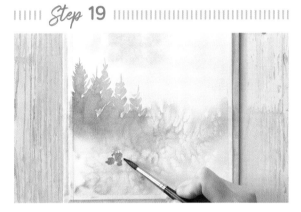

We will now add the wildflowers. With the rose, paint small dots of different sizes, starting below the wet area.

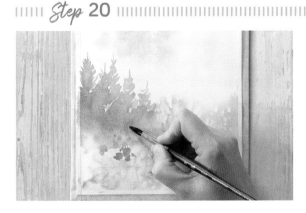

Then do the same on the wet area; the paint will diffuse slightly.

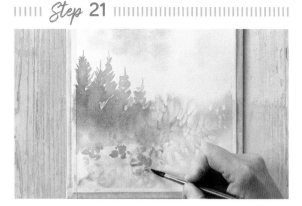

Continue to add larger and larger strokes toward the middle of the paper.

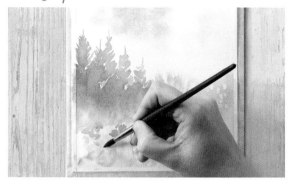

We are going to add some more defined flowers. To paint a petal, start by resting the tip of the brush on the paper.

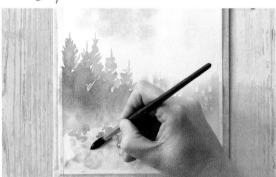

Press the rest of the brush head to create a rounded end. The more you press, the larger the petal will be.

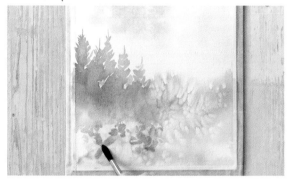

Using this process, add 3 more petals distributed in the shape of a star. Feel free to rotate your paper to stay in a comfortable position.

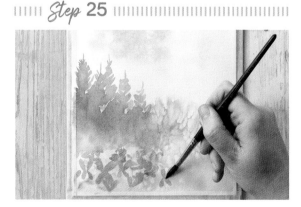

Add 5 more flowers in the same way. Don't try to get a perfect result; the goal is to give a jumbled impression.

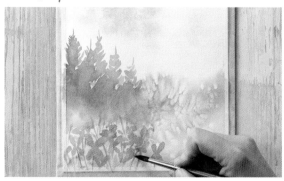

With Sap Green, paint the stems, each time making a line starting from the base of the flower. You don't have to be too precise.

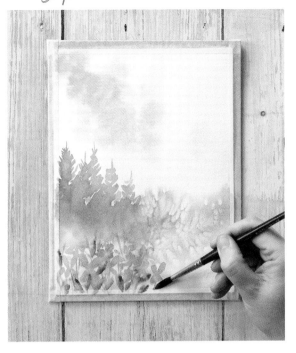

Now add leaves using the same technique as for the petals.

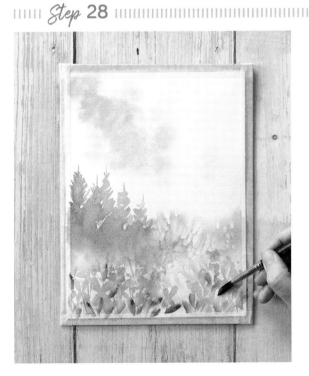

Following the same process, add other flowers to the right side of the meadow. This landscape is now complete!

Learn to Watercolor

First published in the United States in 2022 by Stash Books, an imprint of C&T Publishing, Inc., P.O. Box 1456, Lafayette, CA 94549

© First published in French by Mango, Paris, France—2021

www.mangoeditions.com

This edition of "L'aquarelle" first published in France by Mango Éditions in 2021 is published by arrangement with Fleurus Éditions.

PUBLISHER: Amy Barrett-Daffin

CREATIVE DIRECTOR: Gailen Runge

ACQUISITIONS EDITOR: Roxane Cerda

ASSOCIATE EDITOR: Jennifer Warren

ENGLISH-LANGUAGE COVER DESIGNER: April Mostek

ENGLISH TRANSLATION: Kristy Darling Finder

PRODUCTION COORDINATOR: Zinnia Heinzmann

Printed in the USA

10 9 8 7 6 5 4 3 2 1